SEDALIA

AND THE PALMER MEMORIAL INSTITUTE

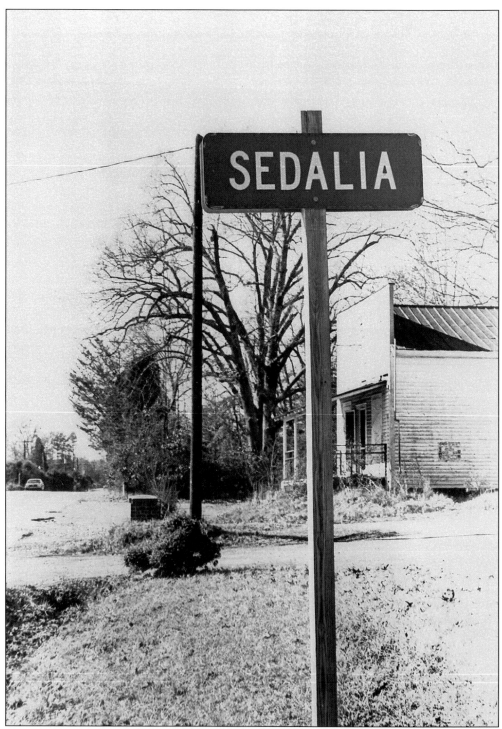

This sign bearing the name of Sedalia, with the Andrews-Paisley Store to the right of the photograph, aptly reflects the bygone era of a small, rural town in America. (Charlotte Hawkins Brown Museum.)

BLACK AMERICA SERIES

SEDALIA
AND THE PALMER
MEMORIAL INSTITUTE

Tracey Burns-Vann and André D. Vann

ARCADIA
PUBLISHING

Copyright © 2004 by Tracey Burns-Vann and André D. Vann
ISBN 978-0-7385-1644-8

Published by Arcadia Publishing
Charleston, South Carolina

Printed in the United States of America

Library of Congress Catalog Card Number: 2004101945

For all general information contact Arcadia Publishing at:
Telephone 843-853-2070
Fax 843-853-0044
E-mail sales@arcadiapublishing.com
For customer service and orders:
Toll-Free 1-888-313-2665

Visit us on the Internet at www.arcadiapublishing.com

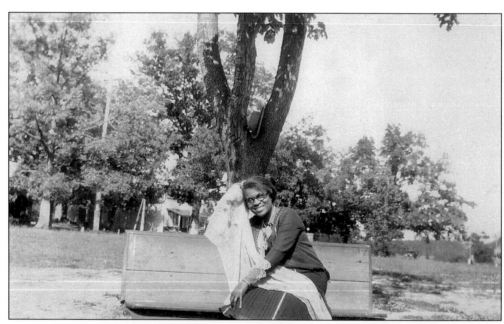

Dr. Charlotte Hawkins Brown is seen sitting on the lawn in front of Kimball Hall. The bench she is sitting on was made by members of St. James Methodist Episcopal Church. Dr. Brown gave the church school benches to use in their new building, and they in turn gave board seats for use on the campus. (Maye Family Collection.)

CONTENTS

ACKNOWLEDGMENTS

This book has benefited greatly from the cooperation, assistance, wisdom, and generosity of scores of persons. This work could not have been completed had it not been for those in the Sedalia community working and rallying behind the book until its completion. The story of Palmer and Sedalia was born out of a desire on the part of my wife Tracey Burns-Vann, director of the Charlotte Hawkins Brown Museum, who in a chance meeting with representatives of Arcadia Publishing talked to them about recording for historical posterity the story of two beloved institutions, Palmer and Sedalia, which are one and the same.

We are indeed thankful to have the "Sedalia Spirit" being put to the challenge by Claude and Ruth M. Totton, who have been virtual encyclopedias on the history and progress of Sedalia.

The story of Palmer and Sedalia is in large measure the story of personal triumphs of the local citizenry. The continuous contributions of their associates, too numerous to mention, are acknowledged in the dedication of this work.

We wish to gratefully acknowledge the assistance of Arcadia Publishing in helping to inform the state and nation about Palmer Memorial Institute and the Sedalia community. We are thankful to have such a talented group of individuals such as Maggie Tiller to guide the work to fruition.

The authors would like to acknowledge several persons who have been instrumental in providing the enthusiasm and support that is needed to complete a project such as this. All of these residents, alumni, and friends gave their time and pictures of the history of these two important organizations: Henry Blackmon, Mabel Cook Pattishaul, Harold H. Webb, Claude and Ruth Morris Totton, Prince and Ruth Smith, Beatrice Maye Mitchell, Ophelia Fuller Jones, Gladys Brown Rennick, Bernice Wilson Jackson, William "Bill" Martin, Daniel Porter, Gretta Greer Martin, Frances Dean, Corrine Williams Brummell, Richard Wharton, Ambassador Robert G. Stone, Frances Darden Crump, Maria Hawkins Cole, Jeanne Lanier Rudd, Eugenia Cox Wheeler, Rep. H.M. "Mickey" Michaux, Carol Hurdle Evans, Nancy Maynard Cheek, Barbara Blayton, Kenneth Arrington, John P. Hawkins, Olvin McBarnette, Loretta Martin Green, Melonie Williams, Nathaniel Lacy, Dr. Gail Wulk, Howard Lee Morgan, George Byrd Jr., Peggy Jones, and Alex Rivera.

There are numerous institutions that were supportive in providing documentation, inclusive of Charlotte Hawkins Brown Historical Foundation, Inc.; Greensboro Public Library; Bethany United Church of Christ; St. James United Methodist Church; North Carolina Department of Cultural Resources and the North Carolina Division of State Historic Sites; Griffith Davis Collection; Duke University; and Sedalia Elementary School.

Last, but not least, the authors are indebted to the staff of the Charlotte Hawkins Brown Museum who have been supportive, inquisitive, and resourceful—namely, Barbara Gibson Wiley and Marian Inabinett.

INTRODUCTION

The town of Sedalia is nestled in eastern Guilford County, 10 miles east of Greensboro and 10 miles west of Burlington, North Carolina. It is located within one mile of two major interstate corridors. Sedalia was incorporated in 1997, 96 years after it received its name. Sedalia's first and only traffic light was installed in 2002, 100 years after the founding of Palmer Memorial Institute (PMI), the school that became synonymous with the town. The town's history is very rich and diverse, and the untold story is fascinating. Sedalia displays a strong New England influence that reflects the faculty, founder, and benefactors of PMI. Even now Sedalia appears as an unassuming rural crossroads between two cities. Drivers on the highway are continually surprised to find the large school campus in the heart of the community.

In 1901, the American Missionary Association (AMA) hired a young woman, Charlotte Hawkins, to come from Massachusetts to teach at a small school in eastern Guilford County that was held at Bethany Congregational Church. The AMA closed the school, and at the request of the local residents, Charlotte Hawkins returned to Massachusetts to raise money for her own school. In 1902, she opened the Alice Freeman Palmer Memorial Institute. Palmer's early years focused on industrial and domestic sciences, and it was the only school for black children in the area. The school continued as a boarding and day school through the 1930s, while Charlotte Hawkins Brown petitioned the State of North Carolina to open a public school for black children in Sedalia. In 1937, the Sedalia School opened next door to PMI. Palmer closed its elementary department and focused on the college preparatory school. The majority of the local residents sent their children to the new public school; with Palmer no longer receiving county funds, the mission changed to admit the best and brightest students from other states. The school would become a world-renowned African-American preparatory school that educated many children from the wealthiest families in the country and six foreign nations. By 1947, *Ebony Magazine* called PMI "The Groton and Exeter of Black America."

The influence of Palmer created a community of highly educated African Americans who became home and land owners at a time when Jim Crow was the order of the day. A community activist, Charlotte Hawkins Brown encouraged home and land ownership by creating a homeowner's association. The association assisted people with purchasing the land, or Brown would buy the land and let them pay her back. Helen Kimball, one of the school's benefactors, purchased 300 acres for the school's farm. Employees of the school were allowed to build on the land and had lifetime rights. Brown was a member of Bethany Congregational Church, but when some members of the community wanted to start St. James Methodist Episcopal Church she gladly gave permission to build on her land and gave desks from the school for seating.

Palmer was the first in the community to have telephone service, but it served as the community telephone. The switchboard was located in the kitchen of the operator's home

in Gibsonville, and anyone needing to use the telephone at Palmer was welcomed. Another Palmer first was the installation of electricity; the lights on campus were often seen burning brightly. Brown fashioned Palmer after Wellesley College, and the tree lined driveways formed what she called her "Little Piece of New England in the South." Palmer also had an economic impact on the area; it was the major employer in Sedalia. One or more members of Sedalia's native families were always working at Palmer.

The community is very closely knit, with generations of the same families still residing there. The people of Sedalia, North Carolina, have passed down cherished memories, from one generation to the next. Educators, institution builders, rural farmers, ministers, and homemakers leave a legacy of leadership that reflects on the community today. The community and the school are so intertwined that they are almost one and the same. This collection of photographs traces the growth, people, and development of a rural Southern community that made an impact on a nation.

This book is dedicated to our families—our parents Richard Burns Sr. and Louise Burns Cherry and Edward C. and Martha Hawkins Vann, and to family members who graduated from Palmer Memorial Institute—and to the pioneers of Sedalia who welcomed Dr. Brown and supported her efforts as she endeavored to create a mecca of education for black youth.

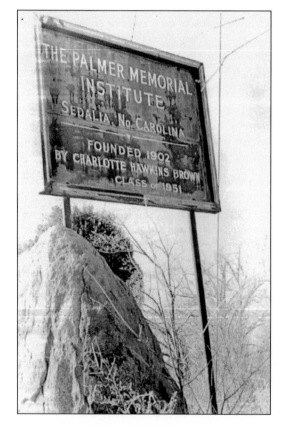

The Palmer Memorial Institute sign, donated by the Class of 1951, greeted visitors to the campus. Located at the corner of Highway 70 and Palmer Farmer Road, it stood until the 1980s.

One

COMMUNITY LIFE

"As much as Palmer Memorial Institute meant for seventy years to many of America's most promising young blacks, it meant even more to Sedalia. The town moved to Palmer's seasons, bloomed with the educational renaissance the school brought and thrived with the fortunes of generations of Palmer graduates. Palmer was Sedalia, it came to be said, and Sedalia was Palmer. Dr. Brown was involved in the full range of community life."

Dr. Marie Hart and Dr. Gayle Wulk,
"Palmer Memorial Institute: The Mission and Legacy," Suite Five Productions.

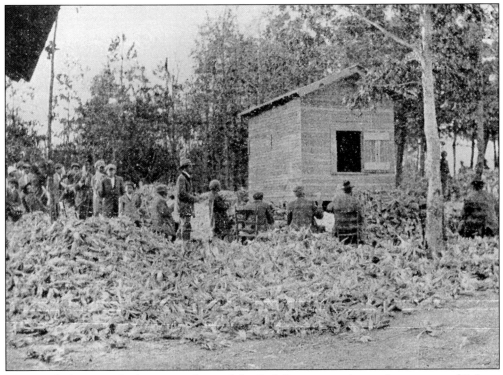

This 1916 photograph shows members of the Sedalia community on the campus of Palmer Memorial Institute involved in "corn husking." (Greensboro Public Library.)

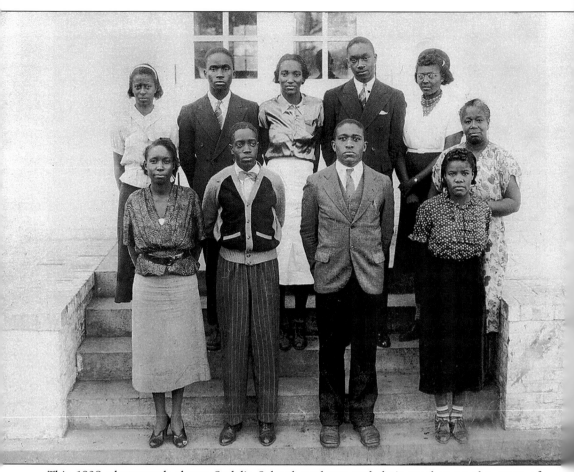

This 1938 photograph shows Sedalia School students and their teacher on the steps of the school. From left to right are (front row) Maye Fuller, Otis Cook, Clarence Beam, and Clara Fryar; (back row) Sarah-Ann Cobb, James Hannah, Louise Sanders Claude Totton, and Beatrice Maye. (Totton Family Collection.)

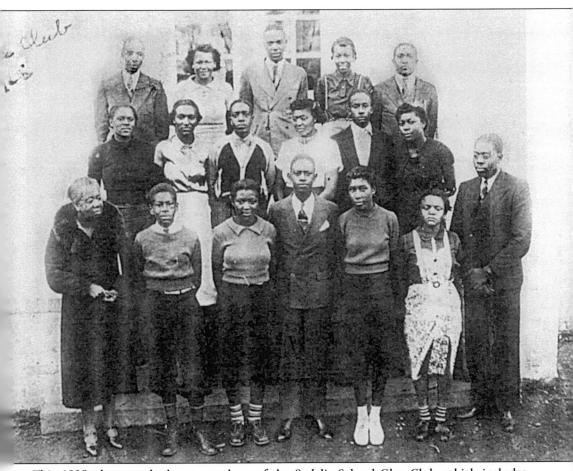

This 1938 photograph shows members of the Sedalia School Glee Club, which includes members of many of the founding Sedalia families. From left to right are (front row) Vina Webb (teacher), Harold Webb, Nevada Hughes, Raymond Totton, Doretta Fox, Lucille Fryar, and Eugene Brice (teacher); (middle row) Bernice Watkins, Louise Sanders, Otis Cooke, Beatrice Maye, Samuel Smith, and Naomi Murphy; (back row) James Hannah, Elizabeth Smith, McKinley Martin, Posie Smith, and Clarence Beam. (Webb Family Collection.)

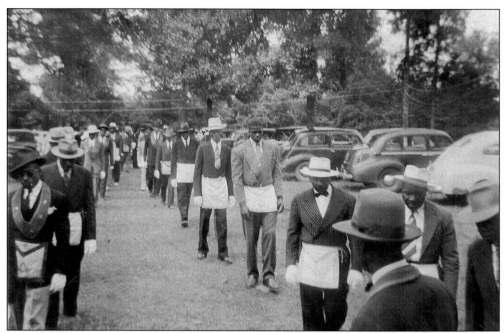

This 1950s photograph captures members of the Prince Hall Masonic Lodge #621 fully arrayed at an unidentified ceremony. (Maye Family Collection.)

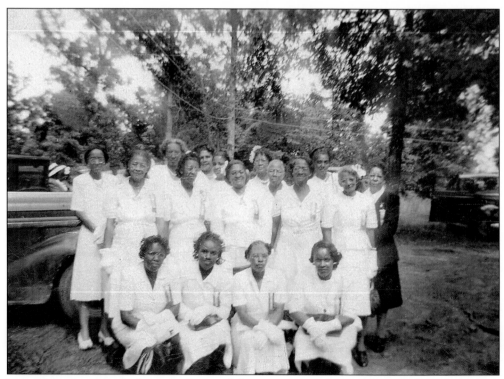

This 1950s photograph shows the ladies of the Eastern Star #510. (Maye Family Collection.)

This Christmas gathering was held in the home of Esther Totton Custer. Juanita Troxler Totton is seen in the immediate left of the photograph, and the couple in the center is Myrtle Foust Lanier and husband William H. Lanier Sr. In the foreground is Jessie Custer, husband of the hostess. (Totton Family Collection.)

This community gathering shows Sedalia residents in Kimball Hall on the campus of Palmer Memorial Institute. Pictured from left to right are (back row) Vina W. Webb and Johnsie Johnson with an unidentified honoree. (Totton Family Collection.)

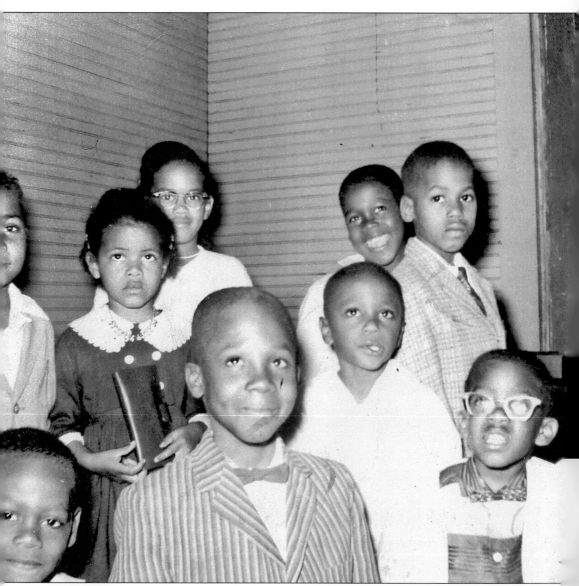

The Sedalia children seen reading in the foyer of Bethany United Church of Christ, from left to right, are (front row) Jimmy Robinson, Aaron Battle, and unidentified; (middle row) Kermit Logan, Cheryl Totton, Joey Robinson, and Eddie Battle; (back row) Toni Totton and Johnny Robinson. (Maye Family Collection.)

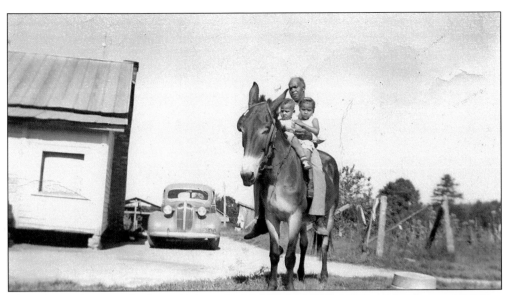

This 1950s photograph shows Robert "Bob" Martin (1888–1976) with his grandchildren Larry Martin and Yvonne Martin on "Emma," the family mule. The Martin family members were sharecroppers on the Clapp's Farm for a period of time and later bought property in Sedalia. He was not only a farmer but also raised horses, cows, pigs, chickens, and rabbits. His first wife, Rosa Zora Richmond Martin, preceded him in death in 1934. He later married Mary L. Williamson Graves in 1947, and together they raised her eight children and three from their union. The entire family attended McLeansville First Baptist Church. (Martin Family Collection.)

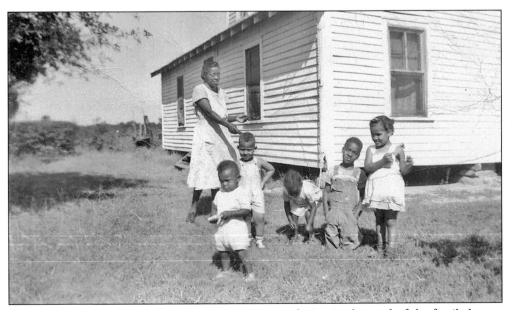

This 1950s photograph shows Mary Graves Martin playing in the yard of the family home. (Martin Family Collection.)

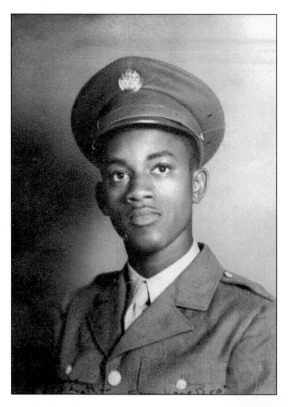

Raymond Daniel Totton (1920–1997), son of Riley and Zula Clapp Totton, is seen in this 1943 postcard photograph that was sent back home to his parents while he, along with six brothers, served in the U.S. Army during World War II. He attained the rank of staff sergeant and received commendations for his service in the European-African-Middle Eastern Theatres, and the American Theatre. He married Juanita Troxler (1925-1989) in 1947. He retired from General Metals Corporation. The community barber and the Palmer barber, Totton was a graduate of Palmer Memorial Institute and attended North Carolina A&T College. (Totton Family Collection.)

Claude Lemuel Totton (b. 1919), the eldest son of Riley and Zula Clapp Totton, is seen in this 1943 photograph. He served as a supply sergeant in the U.S. Army during World War II and European Theatre. He was honorably discharged at the end of the war and returned to Sedalia. Upon his return home, he attended North Carolina A&T College. In June 1948, he married Ruth Morris, a Palmer teacher from Massachusetts; they have been married 56 years. He retired from Lorillard Tobacco Company with 27 years of service and devotes his time to his family, gardening, and raising his pet cattle. He has been a familiar sight in the community on his blue Ford tractor. He is also a deacon emeritus at Bethany United Church of Christ.

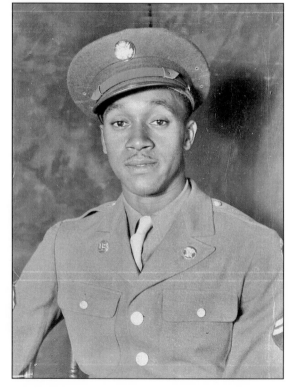

Eric Eugene "Bro" Totton (1925–1994), the youngest son of Riley and Zula C. Totton, is seen in this 1940s photograph during his service in the U.S. Navy during World War II. He was honorably discharged in 1945; he graduated from Palmer Memorial Institute and attended North Carolina A&T College and Howard University. "Bro" was always willing to assist individuals in the community who needed transportation, wherever they needed to go. (Totton Family Collection.)

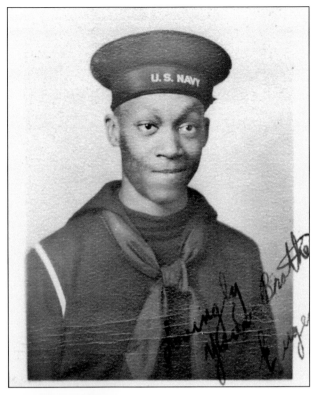

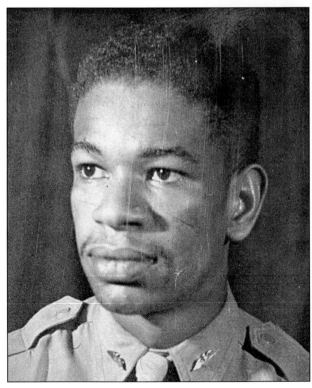

Haywood E. Webb Jr. (1921–1995), son of Haywood E. and Vina Wadlington Webb Sr., is seen in this c. 1942–1943 Pre–Flight Instructor's training uniform. He graduated at the age of 19 from North Carolina A&T College and was the first in his class. He remained there after graduation and taught courses for future pilots known as the "Tuskegee Airmen." After graduate school at New York University he was employed for a number of years as a research engineer in New York. (Webb Family Collection.)

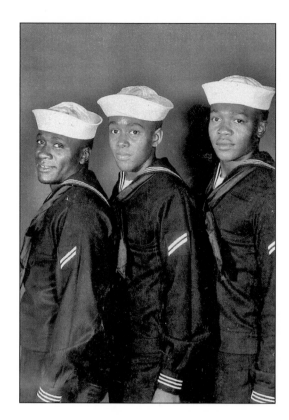

In the center of this 1955 photograph is Howard Lee Morgan (b. 1937) posing with other unidentified individuals in Great Lakes, Illinois, following basic training, while stationed with Company 475. His son Howard Morgan is mayor pro-tem of the town of Sedalia. (Morgan Family Collection.)

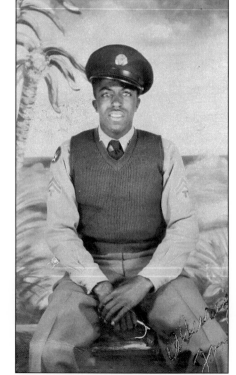

This photograph shows Sedalia native James Fuller, a member of the U.S. Army. (Maye Family Collection.)

Rudolph Richmond, grandson of Joe and Josie Richmond, is seen in this 1951 photograph. (Martin Family Collection.)

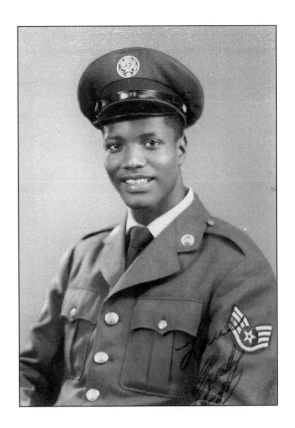

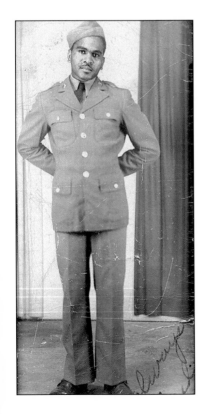

Fred Fuller, son of Wesley and Louella Miles Fuller, rendered service as a member of the armed forces. (Martin Family Collection.)

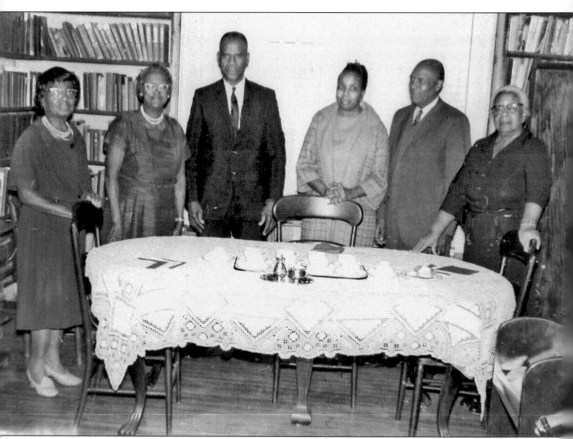

This 1967 photograph shows Sedalia residents and Palmer Memorial Institute graduates gathered in the home of Vina W. Webb. From left to right are Johnsie Smith Johnson (Class of 1907); Zula Clapp Totton (Class of 1905 and first graduate); unidentified; Myrtle Lanier and husband William M. Lanier Sr. (Class of 1922); and Vina W. Webb (Class of 1907). (Totton Family Collection.)

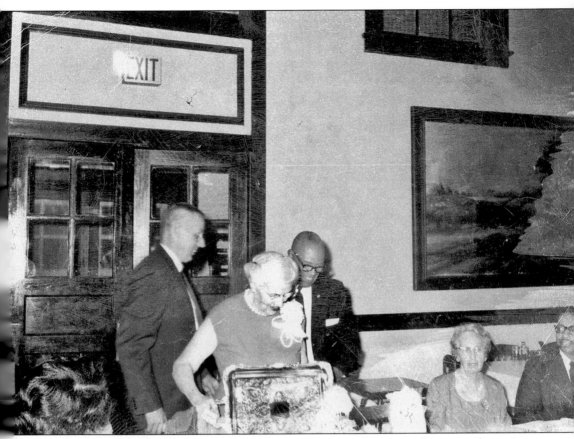

On February 10, 1968, the Sedalia community presented a Testimonial Program honoring Elsie Andrews Paisley for 36 years of devoted service as the postmistress of the Sedalia Post Office. The Sedalia Post Office was established in 1901 with Paisley's mother, Laura Andrews, as postmistress. Paisley herself worked, without benefit of pay, as a clerk. In 1945, she began receiving a small salary for two hours' work daily. In 1947, Elsie Paisley was appointed postmistress and she served in this capacity until her retirement on January 31, 1968. The event was held in Kimball Hall on the PMI campus. Pictured from left to right are (standing) John Paisley (son), Elsie A. Paisley, and William H. Lanier; (seated) her sister Agnes Andrews Peeler and Harold Bragg, president of Palmer Memorial Institute. (Maye Family Collection.)

Vina Wadlington Webb (1890–1986) is long remembered as a noted educator and a civic and religious leader in the Sedalia community. She was married to Haywood E. Webb Sr. and managed to raise four sons while teaching and working as a social worker in Guilford County. A 1907 graduate of Palmer Memorial Institute, she completed her undergraduate education at Bennett College and her graduate education at North Carolina College at Durham. Webb was among the first teachers at the Sedalia School in 1937, where she taught English and history across the state of North Carolina and also directed the glee club, mixed chorus, and other musical groups. Many churches, organizations, and communities sought her talent in piano and voice. She was an active member of Bethany United Church of Christ where she held many offices. She provided piano lessons for young people in the Sedalia community. (Webb Family Collection.)

In 1977 the *Greensboro Record* cited Haywood E. Webb Sr. (1883–1928) (seated, front row). Webb, then 94, was North Carolina A&T College's oldest graduate; all four sons later graduated from the school and held key positions in state and federal agencies. He entered the college in 1904 but his graduation was delayed until 1909 due to the 1905 small pox epidemic that closed the school. Webb taught for 10 years and also entered public life as an agent with the state's Agricultural Extension Service in 1917, serving as the black farm agent for 15 years in Guilford County and later in Alamance and Vance Counties until retirement in 1942. After retirement, he served for 21 years as a desk clerk at Hayes-Taylor YMCA, where he was a role model for countless youth. He is remembered as a leader, organizer, and churchman. His four sons, from left to right, are (seated) Harold Webb; (standing) Reginald Webb, Dr. Burleigh Webb, and Haywood Webb Jr. (Webb Family Collection.)

In 1931, Clarence Exavior Dean (1900–1981) was named teacher trainer and chairman of the Department of Agricultural Education at NC A&T State University, where he remained until retirement in 1967. Professor Dean, along with his first wife, moved to the community in 1936 and made lasting contributions to the educational, civic, and religious life of the area. He was a graduate of Hampton University and received graduate training from Iowa State University. In his capacity of teacher trainer, he became one of the pioneer leaders in the development of teacher education and a recognized specialist in rural education. He later met and married Frances Shoffner, an elementary school teacher. Frances retired after 45 years of teaching and currently resides in Sedalia. This photograph captures Clarence and Frances Dean of the Sedalia community. (Frances Shoffner Dean.)

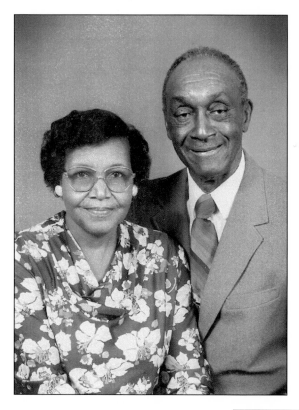

The photograph captures one of Sedalia's second generation: Claude Totton, a native of Sedalia, who can trace his family history back to the late 1860s. His maternal grandparents Daniel and Limmie Close Clapp were slaves on nearby farms in Guilford County. After freedom, they married and raised their family in what later became Sedalia. Mr. Totton is pictured with his wife, Ruth, a native of Boston, Massachusetts. (Totton Family Collection.)

James "Dick" Rudd Sr. (1924–1998), seen in this 1980 photograph with the back of the gym to the right, was a native of Caswell County and later moved with his family to Greensboro, and later to Sedalia. He attended several local schools and was later drafted into the U.S. Army. He was employed at Palmer Memorial Institute for 21 years and was the superintendent of buildings and grounds until it closed in 1971. A noted craftsman and "handyman" in the Sedalia community and surrounding area, he was called upon by all residents for any small task up until his death in 1998. He joined McLeansville First Baptist Church. He remodeled and renovated St. James United Methodist Church, as well as serving as its custodian. He was married to the former Jeanne Lanier for 48 years and was the father of James Jr. (Greensboro Pubic Library.)

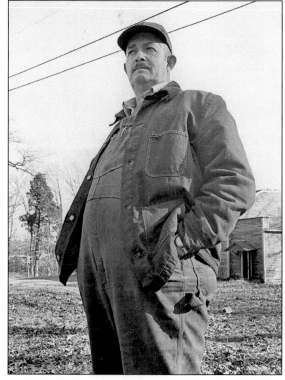

Two

FAMILY ALBUM

"What I most remember was an abiding sense of comfort and security. I got plenty of mothering not only from Pop and my brothers and sisters when they were home, but from the whole of our close knit community."

Paul Robeson, *Here I Stand*, 1958

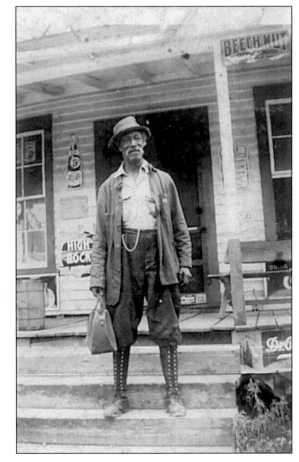

Joseph "Joe" Maye, a lifelong resident of the Sedalia community, is seen here standing in front of the local R.B. Andrews General Store and Post Office. He was a farmer and landowner in the community and worked on the railroad for a number of years. He was married to Amanda Maye and was the father of Joe Maye Jr. and foster father of Charlie E. Maye. (Maye Family Collection.)

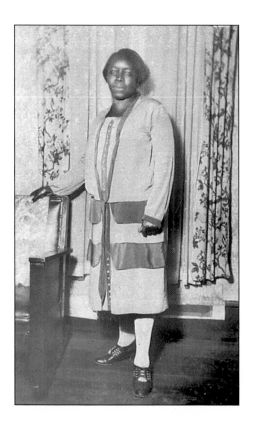

Amanda "Mandy" Maye is seen in this 1930s photograph in the family home. She was married to Joseph Maye of the Sedalia community. (Maye Family Collection.)

Charlie Edward Maye (1900–1969) is seen in this 1920s photograph that was taken in the Cute Studio of Greensboro. He was the foster son of Joseph and Amanda Maye and was born in Guilford County. A lifetime resident of the Sedalia community, he was a member of Bethany United Church of Christ from his youth. In 1922 he married Lola D. Smith and was the father of Beatrice Maye Roberson Mitchell and Elma Maye Gibson. Maye was employed at the Palmer Memorial Institute of Sedalia. Prior to his death, he was superintendent of buildings and grounds and was employed for a total of 45 years of devoted service to the institution. Also, he held active membership in the Prince Hall McLeansville Lodge No. 621 and sang in the Pilgrim Wesley Choir, later renamed Bethany Gospel Choir. (Maye Family Collection.)

Lola Smith Maye (1903–1995) is seen in this photograph holding her daughter Beatrice "Bea" Maye in this late 1920s photograph. Lola was the daughter of John and Mary Jane Smith of Guilford County and as a youth worked for Charlotte Hawkins Brown at Palmer Memorial Institute. She remained at the school until retirement. She was married to Charlie Maye and was the mother of two daughters—Beatrice and Elma. A faithful member of Bethany United Church of Christ, she served in numerous capacities including the Pilgrim Wesley Choir, later renamed the Bethany Gospel Choir. Maye was a charter member of the Five Point Chapter #510, Order of Eastern Stars and was actively involved in the community efforts and projects of Sedalia. (Maye Family Collection.)

John Smith, a local farmer, was an early resident of Sedalia and was actively involved in the Sedalia community. (Maye Family Collection.)

27

Elma "Bo" Maye Gibson (1924–1993) was the youngest daughter of Charlie and Lola Maye. She was a graduate of Palmer Memorial Institute, where she was later employed as assistant registrar. She also attended A&T College, now NC A&T State University. She was married to Floyd Gibson Jr. and was the mother of Floyd III, Barbara, and Beverly Gibson. They made their home in Gibsonville, North Carolina, and later moved to the Sedalia community. She was a member of Bethany Church, where she served in various capacities and was a member of the Brown Memorial Singers. (Barbara Gibson Wiley.)

Barbara Gibson Wiley (b. 1950) is the eldest daughter of Floyd and Elma Gibson. She has the distinction of being one of only two third-generation Palmer graduates. She married Clyde Wiley and has three children: Leslie, Sean, and Craig. Following the Maye Family tradition, Barbara works on the former Palmer campus at the Charlotte Hawkins Brown Museum. (Barbara Gibson Wiley.)

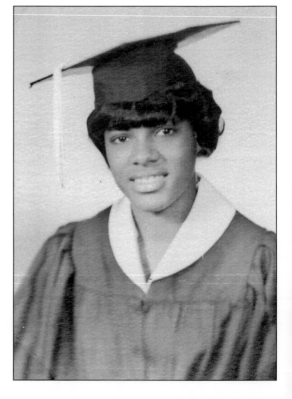

This 1920s photograph shows an unidentified Sedalia resident and Mabel Cook Pattishaul (b. 1908), who was born in McLeansville to Deacon Charles and Alice Cook. She attended Palmer Memorial Institute and is a member of Bethany United Church of Christ. At the age of 95, she was honored with the title of "Mother" of the church and still attends regularly. (Pattishaul Family Collection.)

Dorothy Cox Winston (1926–1995) and Eugenia Cox Wheeler (b. 1925), pictured above, are the daughters of Mabel Cook Pattishaul. Dorothy graduated from Palmer and Bennett College. She retired from the federal government in 1982 and had one child. Eugenia also graduated from Palmer and worked as a civil service employee. She has four children: Rayvone, Jerrold, Gretchen, and Alicia. She currently resides in Sedalia with her mother. (Pattishaul Family Collection.)

Riley Totton (1877–1957) was a native of Rockingham County and a veteran of the Spanish American War, having served in the U.S. Army of Occupation from 1899 to 1902. He was married to Annie Scales (1878–1917) in 1903 and to this union was born five sons (Godfrey, Aubrey, Ezra, Riley, and Sylvester) and two daughters (Esther and Lillie). On June 12, 1918, he was married to Zula Daisy Clapp (1882–1976) of Sedalia. To this union were born three sons (Claude, Raymond, and Eugene) and one daughter (Vivian). Totton was one of the founders of the St. James Methodist Episcopal Church in 1911. He served as superintendent of the Sunday school, steward, and trustee. Early in his career he was a prosperous land owner with various interests such as owning a saw mill and cinder block business and making caned bottom chairs. He is remembered as a community leader and dedicated husband and father. (Totton Family Collection.)

Zula Clapp Totton (1882–1976) was one of three girls who made up the first graduating class of Palmer Memorial Institute, in 1905. She married Riley Totton in 1918. Together they reared 12 children and instilled in them the value of educational pursuit and moral character. Her high school years were spent at Palmer Memorial Institute. She taught school for several years, but after marriage, she devoted time solely to family and church activities. A staunch believer in education, she ensured that all of her children received an education with degrees ranging from high school diplomas to the terminal degree. She was a charter member of Bethany Congregational Church. She served the church and the community in various roles and capacities. Zula Totton was the First Worthy Matron of Five Point Chapter #510 Order of the Eastern Star. (Totton Family Collection.)

Aubrey Lee Totton (1906–1987), the second child of Riley and Anna S. Totton, was raised in the Sedalia community and received his secondary education at Palmer Memorial Institute. He moved to Knoxville, Tennessee, where he graduated from Knoxville College and joined the Omega Psi Phi Fraternity, Inc. He later joined the U.S. Army where he attained the rank of sergeant and served during World War II. He was married to Annetha Vineyard and was the father of Aubrey Jr. He was a faithful member of Rogers Memorial Baptist Church in Knoxville, Tennessee. (Totton Family Collection.)

Dr. Ezra Lester Totton (1908–1996), known as "Professor" or "Totton," was the son of Riley and Anna Scales Totton. Born in 1908 in Sedalia, he received his secondary education at PMI and earned a bachelor's degree at Knoxville College, a master's degree in science from the University of Iowa, and a doctorate in biochemistry–organic chemistry from the University of Wisconsin-Madison. He completed his post doctorate at Stanford University and spent more than 40 years in the field of chemistry, as an educator, researcher, and administrator. In 1949, he went to North Carolina College at Durham and helped to develop undergraduate and graduate degree programs. He was widely published in various scientific publications. Under his direction the department constructed and furnished a $1 million building, which was later named in his honor. Also, he was named professor emeritus and has a scholarship named for him at the university. (Totton Family Collection.)

Carrie Esther Totton Strother (1911–1992), seen here in 1930, is brilliantly attired in her dress upon graduation from high school at Palmer Memorial Institute. The photograph was taken at the noted Harrell's Studio in Greensboro. Nurtured by her parents Zula and Riley Totton, she spent her childhood in the Sedalia community where she attended Bethany Congregational Church. She graduated from Bennett College in 1934 with a degree in home economics and early childhood education. She taught a few years in rural North Carolina, before marrying Theodus Strother and moving to Bronx, New York. She retired in the mid-1970s and returned to her native Sedalia and resided there until her death. (Totton Family Collection.)

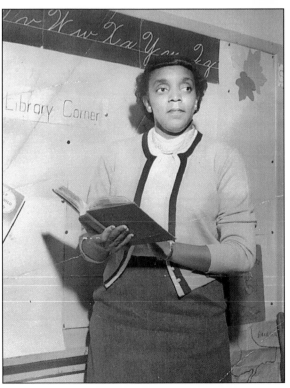

Esther Viola Totton Custer (1915–2002) was the daughter of Zula and Riley Totton, a 1935 graduate of PMI, and a 1937 graduate of the Junior College. In 1941 she graduated from Bennett College in Greensboro. She completed the master's degree at New York University. As a youth, she joined St. James Methodist Episcopal Church. She taught for over 35 years in Harnett County, North Carolina. On weekends when she returned to Sedalia, she was an excellent hostess, whose house often was used as the social center of the community. Esther was known for her gardening, raising beautiful flowers, and canned goods, as well as for her pickles. She was married to Jesse Custer, a native of Springfield, Ohio, who was stationed in Fort Bragg, North Carolina. (Totton Family Collection.)

Vivian Totton McQueen (1922–1978), the youngest daughter of Riley and Zula Clapp Totton, was reared in the Sedalia community and graduated from Palmer Memorial Institute and North Carolina A&T College. Beginning in her youth, she participated in many community activities and was a faithful member of Bethany United Church of Christ. After moving to Washington, D.C., she married Vascar McQueen and was employed for several years by the U.S. government. (Totton Family Collection.)

Claudia E. Totton Barksdale (1948–1997), seen in her graduation photograph from PMI in 1966, became the third generation of her family to graduate from the institution. Her grandmother was the first graduate (Zula Clapp Totton) in 1905, and numerous aunts, uncles, and cousins are among the graduates as well. The daughter of Claude L. and Ruth Morris Totton, she attended Sedalia Public School and completed grades 7 through 12 at PMI. Claudia attended Mundeline College in Illinois and then transferred to Spelman College in Georgia. While there she married J.L. Barksdale Sr., and they became the parents of Jonathan Jr. and Jeremy Barksdale. In 1980, she returned home to Sedalia and was employed with the IRS for a number of years. She was a faithful member of the Bethany United Church of Christ and became the founder, director, and pianist for the Inspirational Choir. Also, she was a member of the Brown Memorial Singers. (Totton Family Collection.)

Robert Lemuel Totton (b. 1957) is the son of Claude and Ruth Totton and is a graduate of Northeast High School. He married his high school sweetheart Zannie Womack, and together they have three sons: Christopher, Gregory, and Robert Jr. He served in the U.S. Army, and the family resides in Greensboro. (Totton Family Collection.)

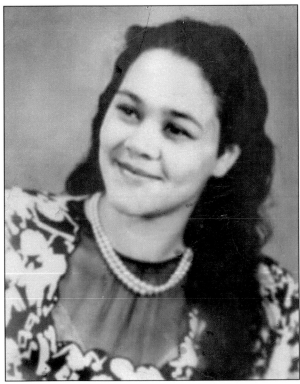

Juanita Troxler Totton (1925–1989) was the daughter of Albert and Nannie Chavis Troxler of the Mount Zion community in Guilford County. She graduated from North Carolina A&T College, was a member of Phi Beta Kappa National Honor Society, and graduated with the highest honors. She married Raymond D. Totton on April 15, 1949, and moved to Sedalia. Juanita and Raymond had two children, Toni and Cheryl. Juanita was a member of Bethany United Church of Christ; while there she was active in many functions. She retired from the Greensboro Public School System. Juanita was a very active member in the Sedalia community and the Sedalia Civic Organization. (Totton Family Collection.)

This is a 1953 photograph of young Toni Rickelle Totton, who is the daughter of Raymond and Juanita Troxler Totton. She married Morris Lamberth and had two sons, Kevin and Ian. She and her sons have made Sedalia their home. (Toni Totton Lamberth.)

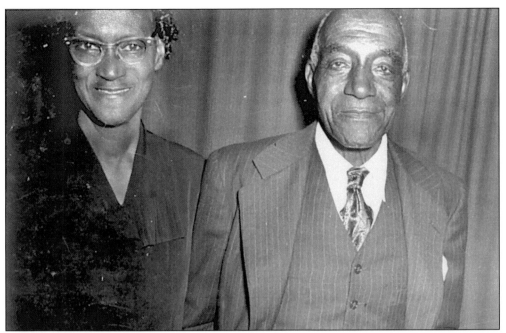

Seen in this 1957 photograph is Zula Clapp Totton with her brother Henry Clapp. Natives of Sedalia, they were the children of Daniel and Limmie Close Clapp. (Totton Family Collection)

Cora Clapp Jackson (left) is seen with her daughter Myrtle Jackson Simon. Cora was the daughter of Sedalia natives Daniel and Limmie Close Clapp, who were farmers and large landowners in the Sedalia community. (Totton Family Collection.)

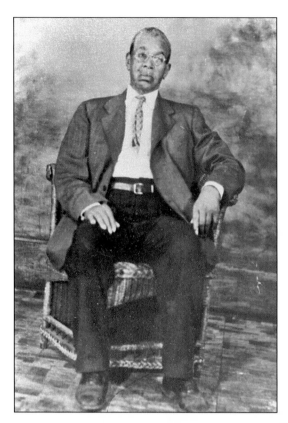

George Washington Wadlington (1856–1956), seen here in the 1950s, was an active participant in the affairs of Sedalia and neighboring McLeansville. He was married to Louisa Wharton Wadlington and was the father of Vina Wadlington Webb of Sedalia. (Webb Family Collection.)

Vina Wadlington Webb (1890–1986), seen here in a 1912 photograph, was the youngest daughter of George W. and Louisa W. Wadlington. She was born in McLeansville and educated at the historic Palmer Memorial Institute in Sedalia, having graduated in 1907 at the age of 16. She would go on to remain a major force in the Sedalia community for over 70 years. (Webb Family Collection.)

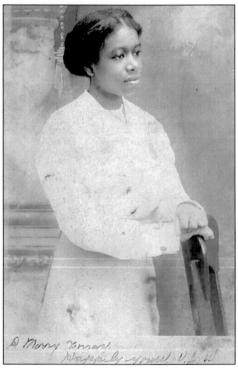

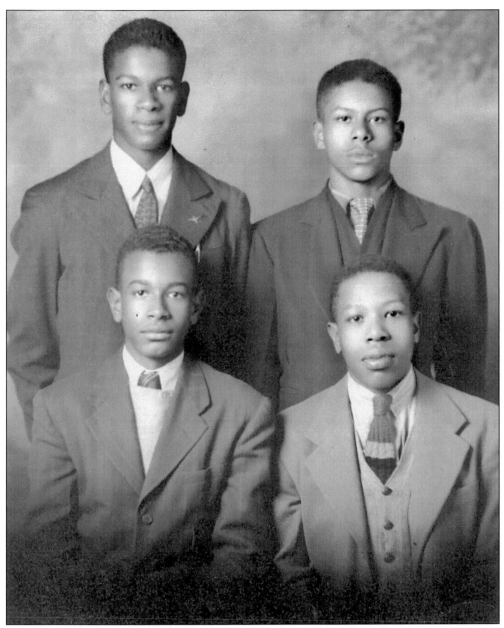

The sons of Haywood and Vina Wadlington Webb, from left to right, are (front row) Reginald and Burleigh; (back row) Haywood Jr. and Harold Webb. All four sons followed in their father's footsteps and graduated from NCA&T College. All became successful leaders in their respective fields. Reginald served with the Office of Administration and Management with the Department of Housing and Development. Burleigh served as the Dean of the School of Agriculture at North Carolina A&T State University for a total of 31 years. Haywood Jr. was a physical research scientist with the U.S. Air Force. Harold became the first African American to serve as Director of Personnel for the State of North Carolina. Also, Burleigh and Reginald received their early schooling at PMI, while Haywood Jr. and Harold attended Henderson Institute in Vance County, North Carolina. (Webb Family Collection.)

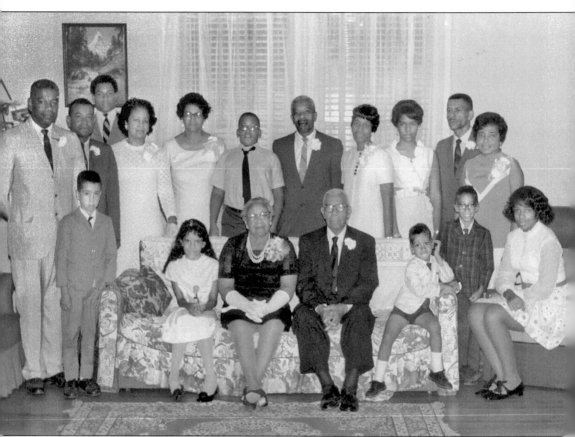

On September 1, 1968, Haywood and Vina Wadlington Webb celebrated their 50th anniversary at a grand affair at their home in Sedalia on Burlington Highway. The couple married on September 8, 1918 and had four children. The 1978 affair was hosted by their children and their spouses, and many out-of-town guests joined relatives, friends, and community residents in the celebration. Mr. and Mrs. Webb were active members of Bethany Church and involved in numerous civic, religious, and philanthropic endeavors in the Sedalia community. (Webb Family Collection.)

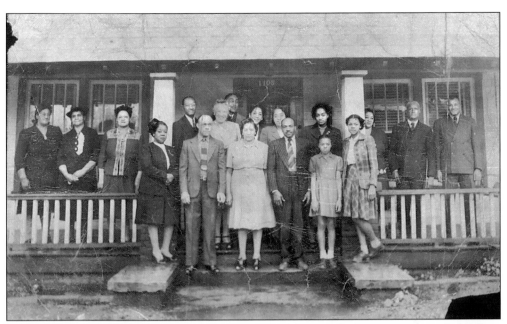

Pictured here are all of Jesse and Cora Rudd's children with their spouses and children. (Matier Family Collection.)

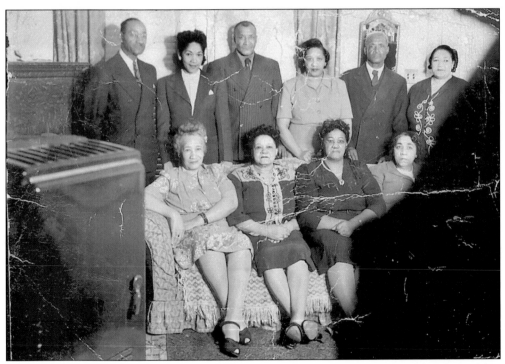

This 1940s photograph captures the children of the Sedalia natives Jesse and Cora Rudd in the family home. Sitting from left to right are Lillie Rudd, Sarah Rudd, Luna Rudd Brooks, and Callie Rudd Matier; (standing) Farrell Rudd, May Rudd, Clarence Rudd, Florence Rudd, Philip Rudd, and Nellie Rudd. (Matier Family Collection.)

This 1950s photograph captures Coy Rudd, son of Forrest Rudd of the Sedalia community. (Totton Family Collection.)

James Rudd Jr. (b. 1951) is the son of James "Dick" and Jeanne Lanier Rudd of the Sedalia community. James is a familiar face in Sedalia today; he's often seen sitting near Burlington Road where he waves to those he knows as they pass by. (Maye Family Collection.)

This photograph captures Alfred Matier in his stripped suit posing for the camera. (Martin Family Collection.)

This early 1900s photograph shows an unidentified member of the Morgan family. The Morgan family came to Sedalia in the 1920s with the Robert Martin family from Caswell County. Lawson Morgan (1877–1975) and Sarah Jane Bigelow Morgan (1881–1956) were the parents of Susie V., Carter, Revena, McIver, and an adopted daughter, Irene. (Morgan Family Collection.)

Ravena Morgan, daughter of Lawson and Sarah Bigelow Morgan, was a 1930 graduate of Palmer Memorial Institute.

McIver Morgan (1917–1980), daughter of Lawson and Sarah Bigelow Morgan, is seen in this 1920s photograph, which was taken in Harrell's Studio in Greensboro. She was a 1934 graduate of Palmer Memorial Institute. (Morgan Family Collection.)

45

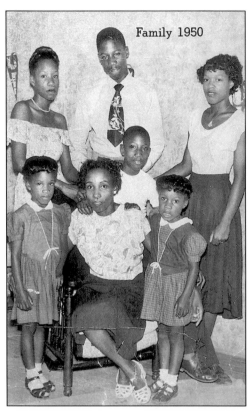

Family 1950

This 1950 photograph captures Sedalia resident Willie Mae Collier Fuller, the wife of Grady Fuller, surrounded by their children for this family photograph. Mrs. Fuller provided hair care for Palmer Girls in Galen Stone Hall. From left to right are (front row) Ophelia, Willie Mae, and Helen Fuller; (middle row) Albert; (back row) Greta, Grady Jr., and Jewel. (Ophelia Fuller Jones.)

Adline Maynard was instrumental in establishing St. James Episcopal Methodist Church. (Nancy Maynard Cheek.)

This is a photograph of James Lawson (1922–1990), son of Willie and Fannie M. Martin, and Gretta Greer Martin (b. 1925), the daughter of Clarence and Florence Smith Greer. She later was reared in the home of her grandparents John and Mary J. Smith. Her early schooling was done at Palmer Memorial Institute, and she graduated from Sedalia High School. At the age of 16 she moved to Washington D.C. On August 10, 1951, she married James Lawson Martin, and they were foster parents to Willie, Cynthia, and Maxine Jones. They held membership at the McLeansville First Baptist Church. Gretta Martin worked in the kitchen and laundry room at Palmer, and James Lawson was vice president of Wire Products in Greensboro. (Gretta Greer Martin.)

Thomasean Maynard Martin (1916–1997) was born in Sedalia and was the daughter of George Washington and Adline Allen Maynard. She received her education at the Palmer Memorial Institute, where she graduated in 1935. She then attended Bennett College. Thomasean was a member of St. James United Methodist Church and was married to Johnnie Martin; they made their home in the Sedalia community. (Nancy Maynard Cheek.)

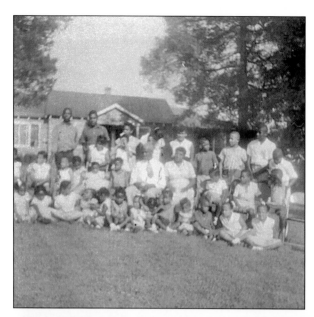

This 1960s photograph was taken at the first Martin family reunion in front of George Byrd's home on Sedalia Road. Robert "Bob" and Mary Graves Martin, seated in the center of the photograph, are surrounded by all of their grandchildren for this family snapshot. (Iona Byrd Collection.)

Daniel Porter and his late wife Barbara Anne Porter came to the community in 1967 and have been involved in their adoptive home. Pictured from left to right are (front row) Daniel Porter and Barbara Anne Porter; (back row) Daniel Jr. and Stephanie Porter. Daniel Porter Sr. is currently a member of the Ebenezer United Church of Christ in Burlington and is known throughout the area as a noted and gifted bass singer, especially in the Brown Memorial Singers. He is often asked to sing "Sending up My Timber" in churches throughout the area. (Daniel Porter.)

Three

PALMER MEMORIAL INSTITUTE

A memorial plaque to Dr. Brown bears the following inscription:

Dr. Charlotte Hawkins Brown Founder and Builder of the Alice Freeman Palmer Memorial Institute, Leader of Women in their Quest for Finer and More Productive Living – Mentor, by Her Writings, of Those Seeking to Live More Graciously – By Her Eloquence, Inspired by Youth to Nobler Achievements, By Her Vigor of Mind and Force of Character, Champion for a Disadvantaged Race in its Striving for Human Rights and Adult Responsibilities. She Gave 58 Years Completely of Her Unique Energies and Talents to the Building of This Institute from its Humblest Beginnings in an Old Blacksmith Shop. Her Vision, Dedication, Singleness of Purpose, and Undaunted Faith Made this School Possible in Her Native State – North Carolina. May Her Memory in Turn Lend Inspiration Always to this Place and its People.

Richard Wharton, former chair, Board of Trustees, Palmer Memorial Institute;
board member, Charlotte Hawkins Brown Historical Foundation

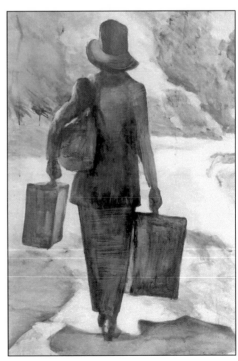

This picture depicts the arrival in McLeansville, North Carolina from Cambridge, Massachusetts, of the young Charlotte Hawkins in 1901. She walked four miles, out to the main road, where she caught a ride in a horse-drawn wagon to the Bethany Institute housed in Bethany Church in Sedalia. When Bethany Institute closed, she went back to Cambridge and raised funds and returned to Sedalia where she continued to educate the local children in her own school, which became the Alice Freeman Palmer Memorial Institute. (Charlotte Hawkins Brown Museum.)

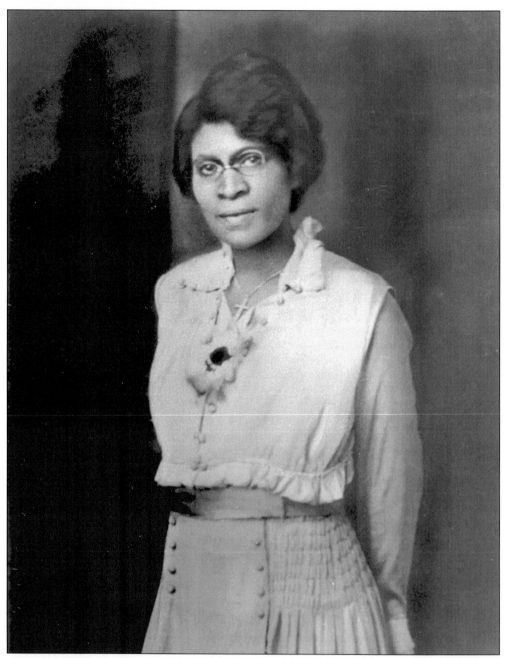

Charlotte Hawkins, pictured here in 1905, founded the Alice Freeman Palmer Memorial Institute in 1902. She named the school in honor of her sponsor and mentor. (Charlotte Hawkins Brown Museum.)

Alice Freeman Palmer (1855–1902), the second president of Wellesley College in Massachusetts, sponsored Hawkins to attend Salem State Normal School. Mrs. Palmer died in December 1902, shortly after Hawkins was in New England raising money for her school in Sedalia. After speaking with George Palmer, Hawkins named the school in his wife's honor. (Charlotte Hawkins Brown Museum.)

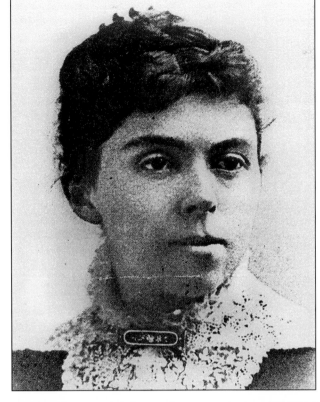

This early 1905 photograph captures the entire student body on the porch of Memorial Hall on the campus of Palmer Memorial Institute. (Greensboro Public Library.)

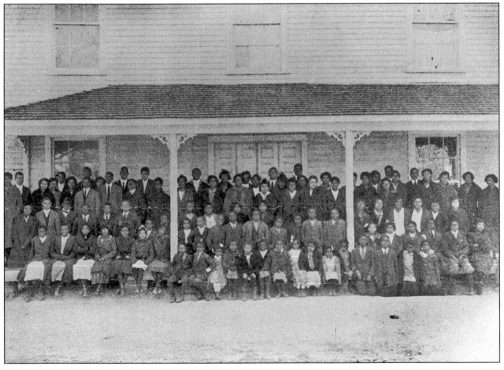

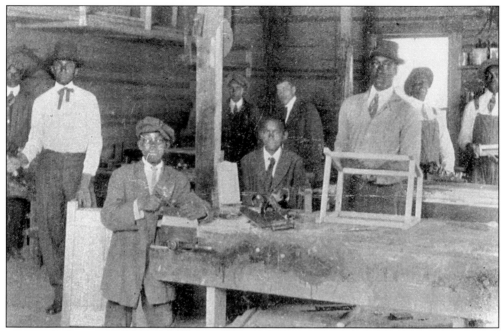

Palmer's emphasis in the early years was on industrial and manual training. Pictured above is an early woodworking class. Students learned how to raise the crops they ate and to make needed repairs to buildings and furnishings. In 1906, Helen Kimball purchased a 200-acre farm for the school. By 1907, the school Hawkins founded had become stable due to farm sales that provided income for the school. Palmer expanded its agricultural and manual training program, a move that pleased white benefactors. (Greensboro Public Library.)

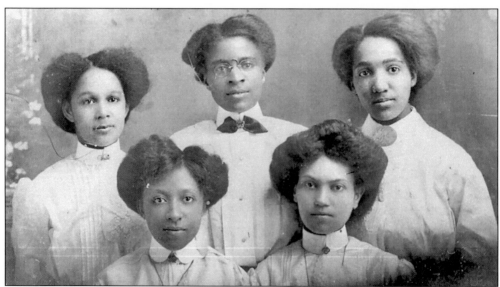

Charlotte Hawkins (top center) is seen in this 1907 photograph with early faculty of the school. Leila B. Ireland (front right) was recruited by Hawkins to teach at Palmer. Also in 1913, she was appointed Jeanes Supervisor of Schools in Henderson, North Carolina, in Vance County, hometown of Charlotte Hawkins. (Charlotte Hawkins Brown Museum.)

Charlotte Hawkins (far right) traveled to New England with Palmer faculty in the summers to raise money for the school. In 1911, she married Edward S. Brown, a student at Harvard. (Charlotte Hawkins Brown Museum.)

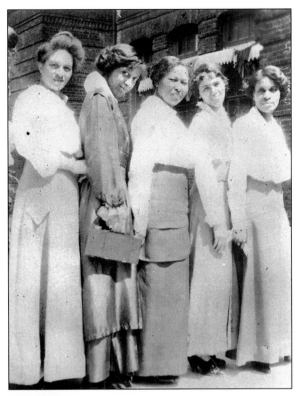

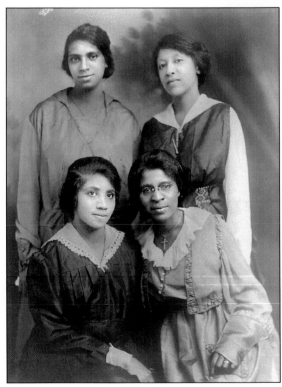

The Sedalia Quartet traveled throughout the East Coast region, singing to raise funds for Palmer. They were well received by enthusiastic audiences everywhere they performed. Charlotte Hawkins Brown (lower right) used the concerts to promote the school and attract donors. (Charlotte Hawkins Brown Museum.)

This 1920s photograph is of the Palmer Memorial Institute male quartet. The group helped to raise funds for the school much like the famed Fisk "Jubilee" Singers. To the extreme right in the photograph is Grady Fuller of the Sedalia community. Other members are Edgar Flood, James Sparks, and Ollie Parker. (Ophelia Fuller Jones.)

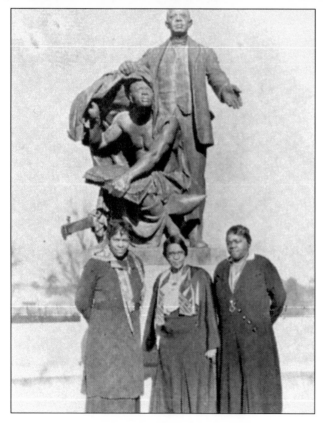

Nanny Helen Burroughs (1879–1961), Charlotte Hawkins Brown (1883–1961), and Mary McLeod Bethune (1875–1955)—"Three Bs of Education"—were photographed while visiting Tuskegee Institute. (Charlotte Hawkins Brown Museum.)

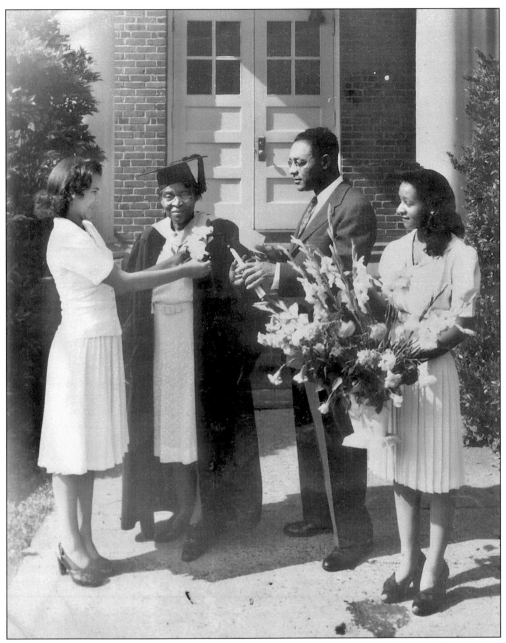

Students and faculty in 1943 prepare for commencement exercises. Pictured from left to right are Yvonne Partee, class of 1945; Dr. Brown; Clifford Brummell, teacher; and Mary Reynolds, class of 1945. (Charlotte Hawkins Brown Museum/Corrine Williams Brummell.)

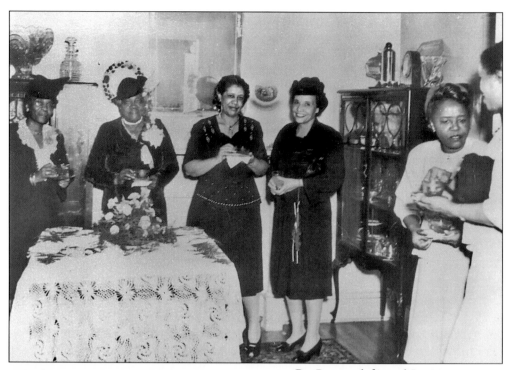

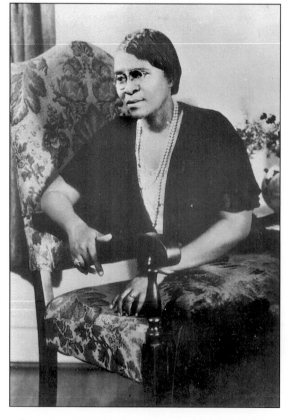

Dr. Brown (left) and Dr. Mary McLeod Bethune (second from the left) are pictured at the home of Grace Donnell Lewis in Greensboro. Mrs. Lewis hosted a meeting of the National Council of Negro Women, *c.* 1945. (Charlotte Hawkins Brown Museum.)

Brown is pictured here in the 1920s. (Charlotte Hawkins Brown Museum.)

Dr. Charlotte Hawkins Brown (at piano) is seen here enjoying a light moment with students and her grandniece, Carol "Cookie" Lane, in 1947. The photograph was taken in her home, Canary College. (Griffith Davis Collection/Duke University.)

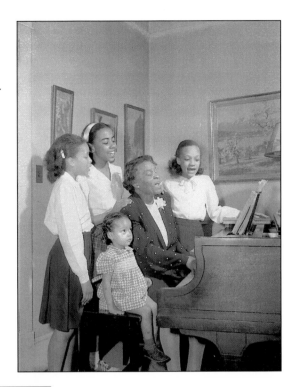

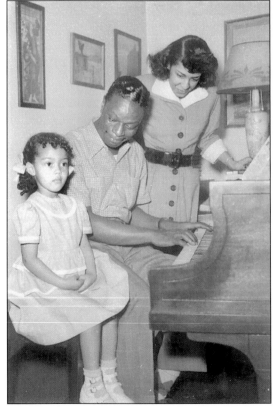

Carol "Cookie" Lane, Nat "King" Cole, and Maria Hawkins Cole (Class of 1941) enjoy a moment at the piano in Canary Cottage, c. 1950s. Maria Hawkins Cole is the daughter of Brown's brother Mingo Hawkins. She was raised in Canary Cottage along with her sisters Charlotte and Carol. Cookie is the daughter of Maria's sister Carol, who is now deceased. (Alex Rivera.)

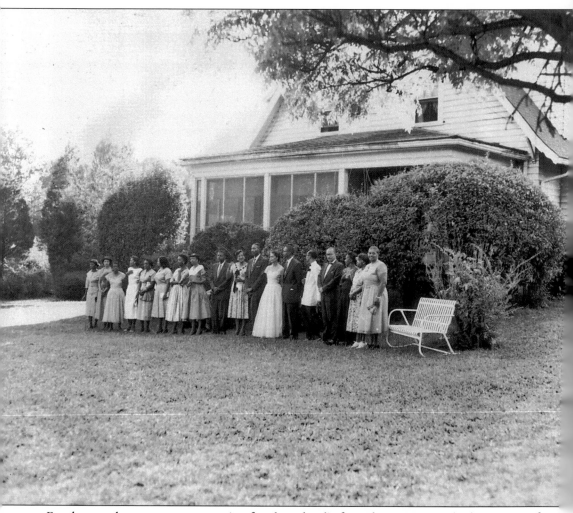

Faculty members are seen preparing for the school's formal opening. At the beginning of each school year, students introduced themselves to the faculty and staff at a reception on the lawn of Canary College. Pictured from left to right are Lucretia Hardy, Lois Taylor, unidentified, Ruth Morris Totton, unidentified, Juanita Looney, Georgia Armstrong, Ruth Harmon, Dr. Alfredo Sharpe, Pricilla Tobin, Charles Bundridge, Lois Higginbotham, Bernard Battle, Richard Skeete, Max Dardeau, Ollie Burnside, Brown, and Wilhelmina Crosson, *c.* 1955. (Alex Rivera.)

Carol Lovette Brice, the daughter of Rev. Dr. John and Ella Hawkins Brice, is seen in this photograph admiring the bust of Alice Freeman Palmer with Dr. Mordecai W. Johnson, eminent president of Howard University. Carol was a cousin of Dr. Brown but was raised as her niece. She graduated from Palmer's High School in 1933 and Junior College in 1935. (Alex Rivera.)

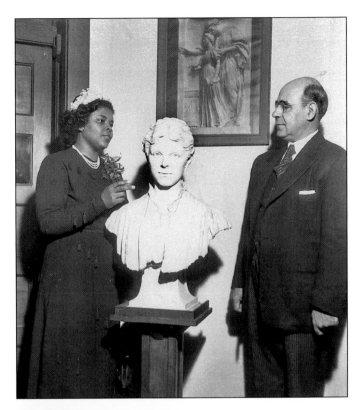

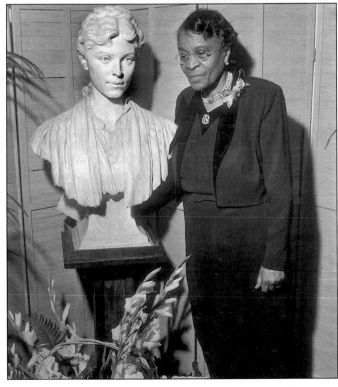

In this 1955 photograph, Dr. Brown is seen standing beside the bust of Alice Freeman Palmer inside of the Palmer Building. (Alex Rivera.)

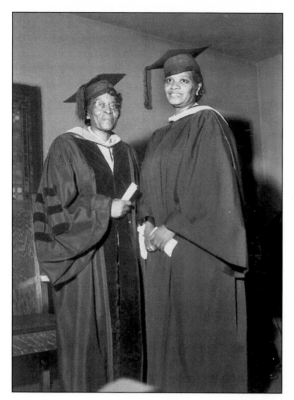

Dr. Brown, founder and president emeritus, and Wilhelmina Crosson (1900–1991), president, are pictured in Wellesley Auditorium in the Alice Freeman Palmer Building, *c*. 1955. Crosson received a bachelor's degree from Boston Teachers' College in 1934 and a master's degree from Boston University. Miss Crosson was the first black teacher in the Boston School System. On October 5, 1952, she was tapped by Dr. Brown to lead the college preparatory school. She accomplished great things for the school and retired in 1966 before returning to Boston in 1970. (Alex Rivera.)

Charles W. Bundridge (1921–1997), a graduate of North Carolina A&T College, received a bachelor's degree in business administration and a master's degree in education. In 1952 he became employed as a social studies teacher, basketball coach, and business manager at PMI. He became acting president and remained there until the school closed in 1971. He was a member of Greensboro's St. James Presbyterian Church and the Alpha Phi Alpha Fraternity, Inc. He later served as the vice president of the Charlotte Hawkins Brown Historical Foundation, Inc. (Charlotte Hawkins Brown Museum.)

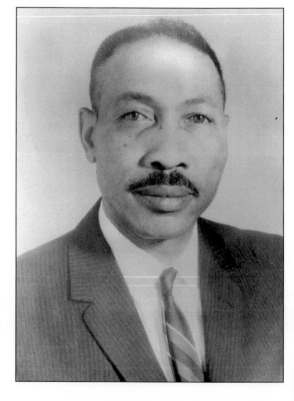

60

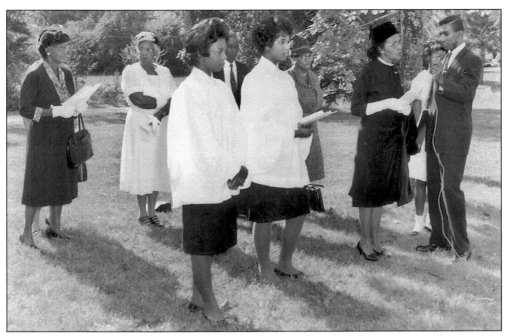

This 1963 photograph shows several generations of Palmer alumni and students at the Founder's Day Ceremony. Pictured from left to right are (front row) two unidentified Palmer students, Naomi Johnson (singer), and Charlie Humphrey (holding microphone); (back row) Zula Clapp Totton (class of 1905), Vina Wadlington Webb (class of 1907), unidentified, and Wilhelmina M. Crosson. (Charlotte Hawkins Brown Museum.)

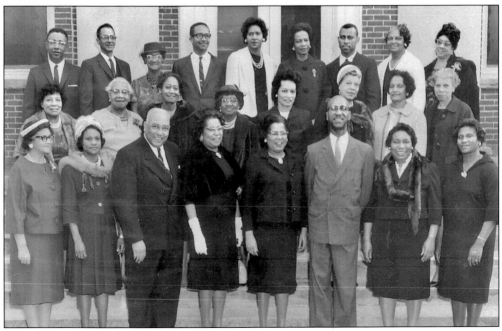

This is a 1960s photograph of the Palmer alumni in front of the Alice Freeman Palmer Building. (Charlotte Hawkins Brown Museum.)

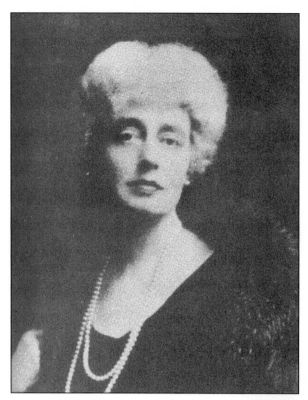

Daisy S. Bright of New York was a supporter of Palmer Memorial Institute. Bright brought guests from her winter residence "Oak Lodge," just three miles from Sedalia, and many of the guests were prominent, wealthy visitors from New York and New England who became interested in helping Dr. Brown. It was through her friend Mrs. Charles M. Confelt that the Galen L. Stones of Boston became interested in the school and became the institution's largest contributors. Daisy Bright's interest in the progress of the institution was the longest of any other benefactor or supporter, except for founder Dr. Charlotte Hawkins Brown. (Charlotte Hawkins Brown Museum.)

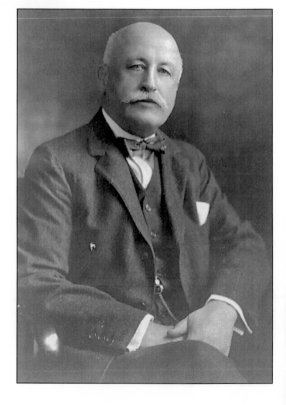

Galen L. Stone (1862–1926), Boston businessman, was Palmer's major benefactor. He had donated well over $500,000 to the school during his lifetime. The girl's dormitory that was built in 1927 was named in his honor. (Ambassador Galen L. Stone.)

Carrie Morton Stone (1866–1945), wife of Galen L. Stone, was a major supporter of Palmer and Dr. Brown. She encouraged numerous friends and associates to give (and give generously) to Palmer. The single female teacher's cottage built in 1948 was named in her honor. (Ambassador Galen L. Stone.)

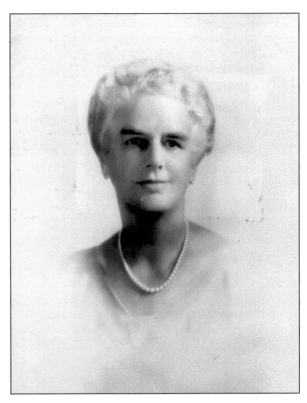

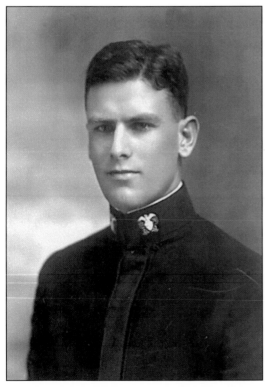

Robert Gregg Stone continued his parents' support of the school through its closing. Gregg Cottage on campus was named in his honor. (Ambassador Galen L. Stone.)

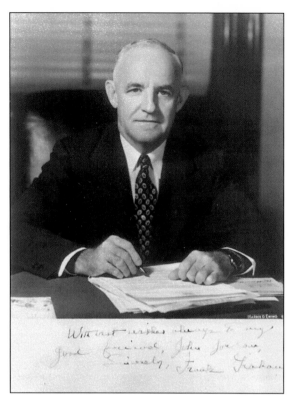

Frank Porter Graham (1886–1972), president of the University of North Carolina at Chapel Hill, was an advocate for Dr. Brown and a Palmer Board of Trustees member. (Charlotte Hawkins Brown Museum.)

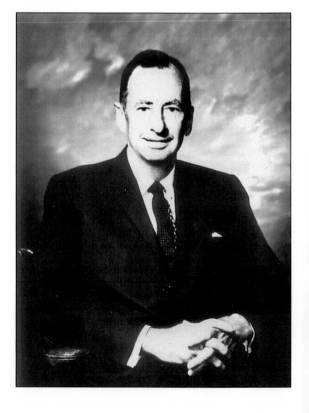

J. Spencer Love (1896–1962) was the founder of Burlington Industries. He and his wife were members of the board of trustees at Palmer. They were second behind the Stones in giving to the school, giving an annual pledge of $2,000 and aiding in the development of the endowment fund. (Charlotte Hawkins Brown Museum.)

Richard Wharton (left) and Cyrus A. Wharton are two members of a progressive Southern family who served as members of the Palmer Board of Trustees. Cyrus A. Wharton was an early member of Palmers' board of trustees, and his son Cyrus R. Wharton and his grandson Richard both served as chairman. Richard Wharton, retired attorney, currently serves on the board of directors of the Charlotte Hawkins Brown Historical Foundation, Inc. (Richard Wharton.)

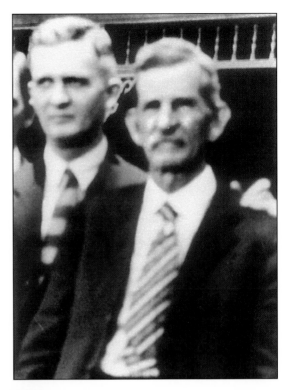

Cyrus R. Wharton was a Palmer trustee and was elected chairman in the 1950s; his son Richard Wharton succeeded him in 1966. According to his son Richard, he and his wife hosted Charlotte Hawkins Brown for dinner in their home. (Charlotte Hawkins Brown Museum.)

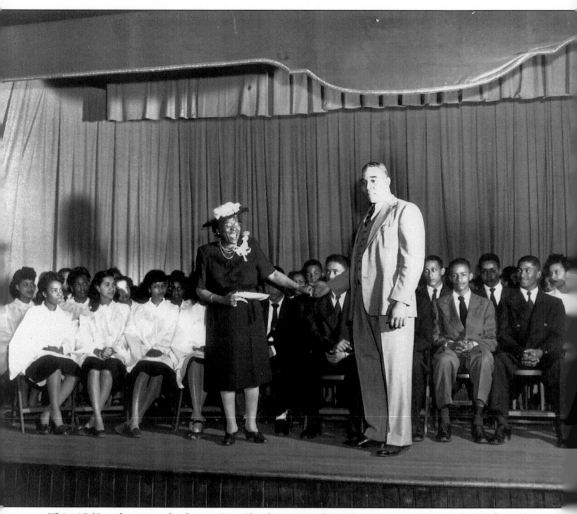

This 1940s photograph shows Dr. Charlotte Hawkins Brown receiving a check from her first cousin and Palmer trustee Dr. John Dewey Hawkins (1901–1988). Dr. John Dewey Hawkins was a graduate of the class of 1925 from PMI. He was a graduate of Johnson C. Smith University and Howard University Dental College. He was elected to the Trustee Board of Palmer in 1935 and served until 1967. His son John Dewey Hawkins Jr. attended Palmer and graduated in 1949. (Charlotte Hawkins Brown Museum.)

Four

Sedalia Buildings and Grounds

*"Fair Palmer, thy sons and thy daughters give cheer
While their voices with rapture do thrill
Thy message so sweet shall forever echo
Its harmony o'er vale and hill;
Dear Palmer, the pride of each rural home
Thus planted on soil all their own;
Where the brier and the cactus once flourishing grew
Stands a tower of wood and of stone."*

First verse of the Palmer Alma Mater—Charlotte Hawkins Brown

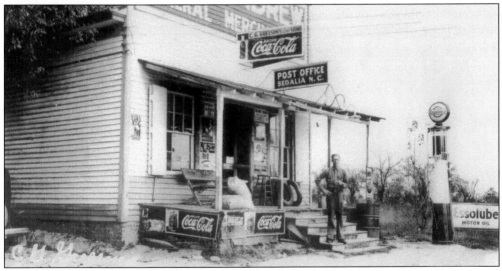

Legend says that Zula Clapp Totton, PMI's first graduate, rode to nearby McLeansville daily to pick up mail. To have its own post office, a town needed a name. Robert "R.B." Andrew, owner of R.B Andrew General Mercantile—the sole store until the 1950s—chose the name, which he took from Sedalia, Missouri, because he liked its sound. Upon Andrew's death in 1929, C.H. Greeson became the store's proprietor. Andrew's daughter, Elsie Andrew Paisley, and her husband next took over and changed the name to Paisley's Store. It was later sold to the Prince E. Smith family. The post office was established February 1, 1901, with R.B. Andrew as postmaster, followed by his wife Laura, and later his daughter Elsie. The structure was later sold, moved, and is preserved as a museum. (Charlotte Hawkins Museum.)

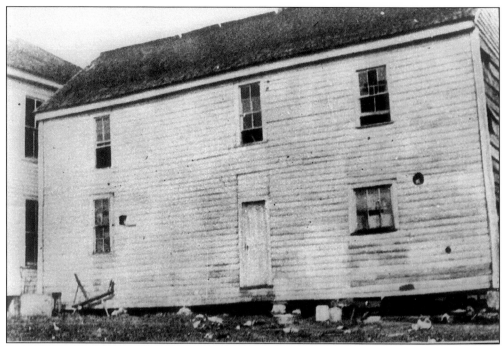

In 1902, Hawkins opened the Alice Freeman Palmer Memorial Institute in this building, which was a former blacksmith shed. The building served as a classroom and dormitory for Hawkins and the female students. She taught her first class in October 1902. (Charlotte Hawkins Brown Museum.)

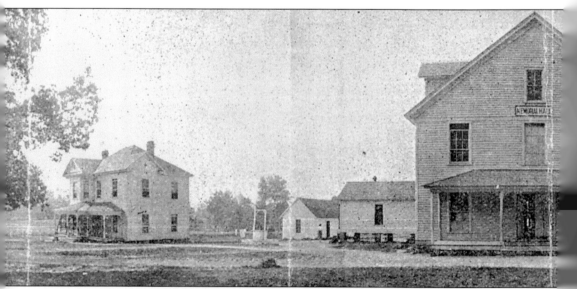

This is a 1915 photograph of the early Palmer campus, which at this time had only wooden structures. From left to right are Grinnell Cottage (domestic science building), Memorial

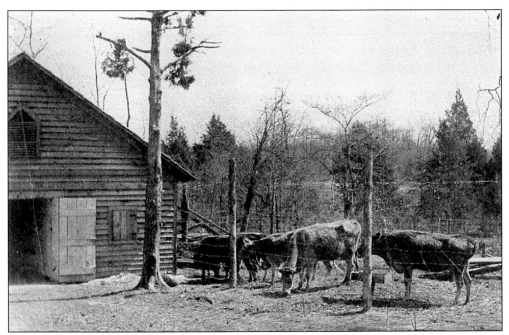

This 1917 photograph shows cows grazing on the dairy farm of Palmer. In its formative years, Palmer's curriculum emphasized manual training and industrial education for rural living. Brown expanded the school to include well over 350 acres of land, including a sizable farm. Charlotte Hawkins Brown offered the most deserving students the opportunity to defray part of the cost of tuition by doing laundry work, kitchen work, dish washing, and working on the farm. As the 1930s came to an end, the aim of the school changed and began to emphasize academic and cultural education. (Charlotte Hawkins Brown Museum.)

Hall (girls' dormitory and classrooms), Grew Hall (boys' dormitory), and Mechanical Hall (industrial training building). (Charlotte Hawkins Brown Museum.)

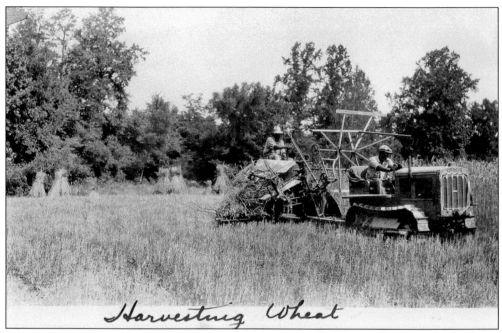

This 1940s postcard shows a local farmer harvesting wheat. (The Martin Family Collection.)

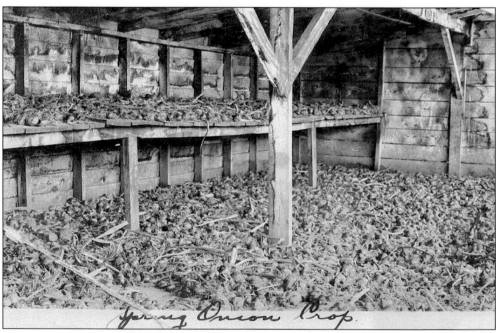

This photograph shows the bounty of the spring onion crop in the barn of one of the local farmers in the Sedalia community. (The Martin Family Collection.)

This mid-1920s postcard shows the main entrance to Palmer Memorial Institute. (Charlotte Hawkins Brown Museum.)

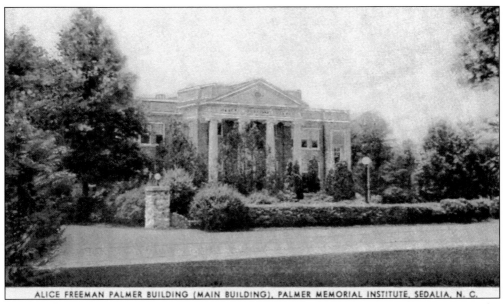

ALICE FREEMAN PALMER BUILDING (MAIN BUILDING), PALMER MEMORIAL INSTITUTE, SEDALIA, N. C.

This is a postcard of the Alice Freeman Palmer Building (1922). The building was named for Alice Freeman Palmer, the second president of Wellesley College and mentor to Dr. Charlotte Hawkins Brown. It was dedicated on April 9, 1922, at a cost of $150,000. Palmer students made 225,000 bricks and cut 75,000 feet of framing and timber for the construction of the building. This building was the heart and soul of the PMI campus—it was the first brick structure on the campus, and it contained administrative offices, classrooms, the Wellesley Auditorium, and a library, which contained an art collection of reproductions of the world's masterpieces. It was destroyed by fire in 1971. (Charlotte Hawkins Brown Museum.)

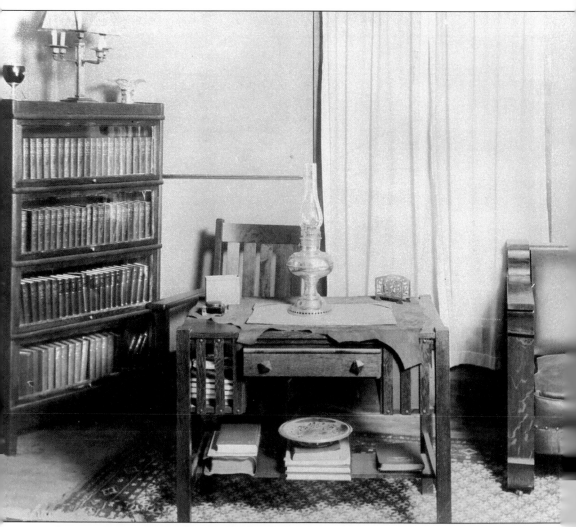

This is a 1930s photograph of the principal's study in the Alice Freeman Palmer Building. Note the simple yet elegant Mission-style furnishings and the volume of classics on display in the bookcase. (Maria Hawkins Cole/Charlotte Hawkins Brown Museum.)

This postcard of Canary Cottage (1927) shows Dr. Brown's personal home. Canary Cottage was a one-and-a-half story, yellow, clapboard house with a steep hipped roof, a screened porch at one end, and a rear kitchen. Here, she and the school's teachers demonstrated to students practical matters about decorating a house. Dr. Brown also hosted social events in her home to provide students with training in the social graces. Canary Cottage has been restored and furnished. Canary Cottage did not officially become the sole property of Palmer until Dr. Brown's death in 1961. (Charlotte Hawkins Brown Museum.)

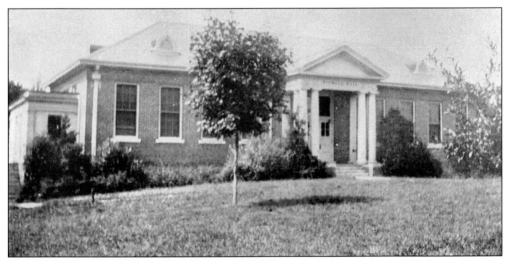

Kimball Hall served as the dining hall and kitchen, and its basement had classrooms for industrial and mechanical arts. Located between the girls' and boys' dormitories, it was named for Helen F. Kimball of Massachusetts, who was among the earliest donors and supporters of Palmer. The dining hall served as the setting for instructing Palmer students in "social graces." As required by "the madam," boys entered Kimball Hall from one side and girls from the other. The basement was used as a cold storage room for vegetables and perishable items—many of which were grown on the Palmer Farm—and also housed a three-room apartment with bath, a school workshop, and a band room. (Charlotte Hawkins Brown Museum.)

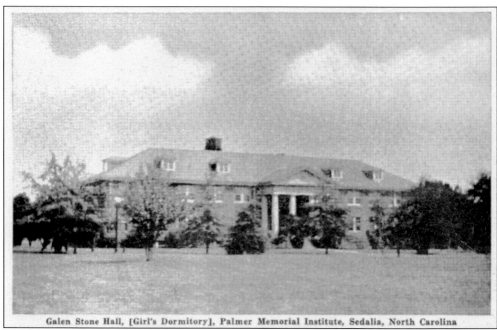

Galen Stone Hall, [Girl's Dormitory], Palmer Memorial Institute, Sedalia, North Carolina

This is a postcard of Galen L. Stone Hall (1927.) The dormitory was built and dedicated in May 1927 along with Kimball Hall on the occasion of the 25th anniversary of the school. It was dedicated in honor of Palmer's largest donor, and Stone Hall served as the school's dormitory for girls. By the time of his death in 1926 Stone had pledged and donated well over $75,000 towards the development of the school. In 1950, Stone Hall suffered a disastrous fire. By the following fall, however, it had been completely renovated for continued use before the next school term. (Charlotte Hawkins Brown Museum.)

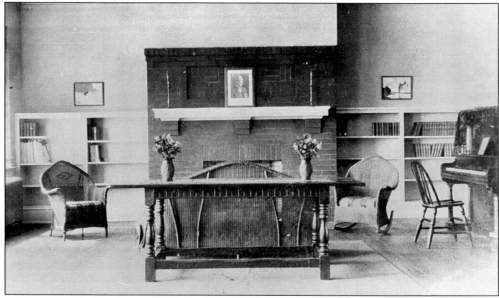

This is an interior view of the living room in Galen Stone Hall as it appeared in the 1920s. (Charlotte Hawkins Brown Museum.)

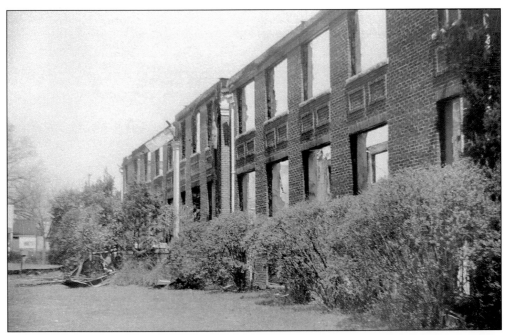

This is a photograph of the Galen Stone Hall facade that was destroyed by fire while the entire student body was away in Greensboro viewing the film *Pinky*. The funds for restoration were secured by a $35,000 to $50,000 insurance policy, a considerable gift from J. Spencer Love, more than $97,000 from the Palmer Executive Committee, and a $40,000 secured loan. Dr. Brown raised funds, and the building was rebuilt in eight months and ready in the fall. (Charlotte Hawkins Brown Museum.)

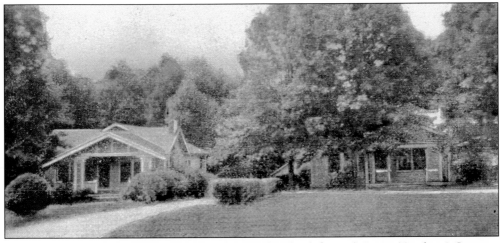

This is a 1930s photograph of present-day Brightside (left) and Gregg Teachers' Cottages (right). Brightside was named in honor of Daisy Bright and was used to house married members of the Palmer faculty. Gregg Cottage, which was named for Robert Gregg Stone, was identical to Brightside Cottage and had a total of 1,124 square feet with the house divided into five rooms with two bedrooms and a bath. It also was used to house married members of the Palmer faculty. Funding for these cottages was secured by Dr. Brown from the American Missionary Association at a total of $7,700. (Charlotte Hawkins Brown Museum.)

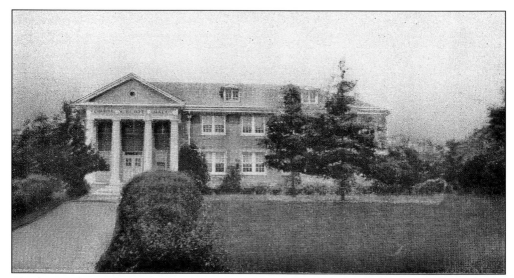

Charles W. Eliot Hall (1934) was a boys' dormitory named for a longtime president of Harvard University who supported PMI. The Eliot family was a large contributor and supporter to Palmer during the early 1920s and 1930s. The building was designed to be identical to Galen Stone Hall, but due to the Depression and the shortage of funds, the building could not be completed. The building was opened in 1934 without a second wing, with half the capacity of Galen Stone Hall. (Charlotte Hawkins Brown Museum.)

Palmer Memorial Institute Gymnasium (1943) was located between Galen Stone Hall and Kimball Hall and served as the center of social functions and sporting events on the Palmer campus. Those events included basketball games and junior and senior prom dances. The wooden structure was partially funded by students and faculty members as a surprise gift for Dr. Brown upon her 40-year tenure at Palmer. The building was condemned in the 1960s and later demolished. (Charlotte Hawkins Brown Museum.)

Massachusetts Congregational Women's House (1948) was designed by Greensboro architect Charles C. Hartmann as a brick veneer Colonial Revival cottage. This dwelling, which served as the girl's home economics practice house, was made possible through the efforts of Daisy Bright, a longtime supporter who had been associated with Dr. Brown from 1903 to 1953, longer than any other donor or supporter in the school's history. This building is nearly identical to the Carrie M. Stone House. As a part of the Palmer curriculum, girls were required to live in the house in six week intervals to learn the finer points of home economics. (Charlotte Hawkins Brown Museum.)

This 1950s view taken from the west window on the second floor of the Alice Freeman Palmer Building shows Eliot Hall in the far distance and Carrie Stone Cottage and Canary Cottage. (Charlotte Hawkins Brown Museum.)

Here students walk the campus of Palmer Memorial Institute heading west towards Eliot Hall. (Charlotte Hawkins Brown Museum.)

Charlie Edward Maye (1900–1969) served for over 45 years as the superintendent of buildings and grounds of Palmer Memorial Institute. Also, he was manager of the farm. It is of note that crops raised on the farm regularly exceeded expectations in regards to the crop productivity of the local area. (Barbara Gibson-Wiley.)

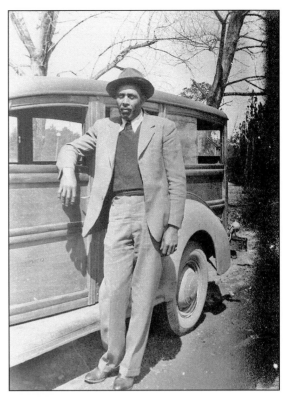

James Rudd Sr. (1924–1998) was employed at Palmer for 21 years and was superintendent of building and grounds when the school closed in 1971. He also gave his expertise to the subsequent owners of the property until he retired in 1988. (Greensboro Library.)

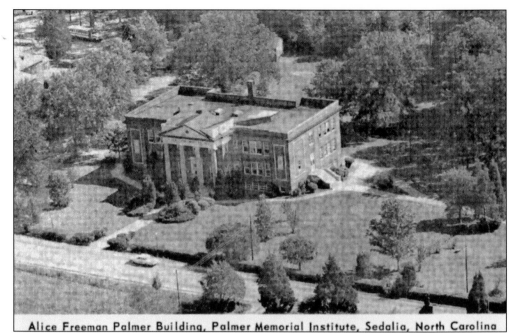

Alice Freeman Palmer Building, Palmer Memorial Institute, Sedalia, North Carolina

This postcard shows a 1960s aerial view of the Alice Freeman Palmer Building surrounded by the scenic and manicured grounds of the campus. (Charlotte Hawkins Brown Museum.)

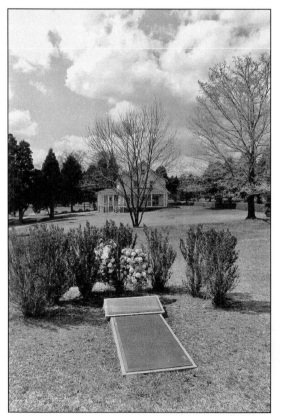

Prior to her death Dr. Charlotte Hawkins Brown requested that she be buried near Alice Freeman Palmer Building. She was laid to rest on Sunday, January 15, 1961; the grave sits on a slope between Canary Cottage and her office in the Palmer Building. The Palmer Board of Trustees voted to draft a resolution noting her contributions and sacrifices in building a world-class institution of learning. It was then inscribed on a plaque and placed on the grave. (Charlotte Hawkins Brown Museum.)

Palmer Memorial Institute was the only school for black children in eastern Guilford County. Dr. Charlotte Hawkins Brown petitioned the Guilford County Board of Education to build a school for the community, and Sedalia Public School was built adjacent to PMI. Once the new school opened, nearly all of the local children became pupils. This move enabled Dr. Brown to transition PMI from a mostly day school to a boarding school and junior college. Beatrice Cole was the first principal at Sedalia with six teachers. The students came from Sedalia, Wadsworth, and McLeansville communities, with the Beulah community students joining in 1939. William H. Lanier, valedictorian at Palmer in 1922 and graduate of Lincoln University, became the second principal in 1953 and served until 1966. In July of 1982 this structure was razed to make way for the construction of seven new classrooms and an office complex. (Sedalia Elementary School.)

The Brice-Webb House on the Burlington Highway served as the original residence of Rev. Dr. John Brice, who served as pastor of Bethany Congregational Church (now Bethany United Church of Christ) from 1926 until 1950. Also, for more than 30 years he served as vice-president and religious director of Palmer Memorial Institute. Later in the 1950s the house was sold to Haywood E. and Vina Wadlington Webb and was maintained by Mrs. Webb until her death in 1986. Years later the property was sold to neighboring Bethany United Church of Christ, which was the wish of the Webbs. (Webb Family Collection.)

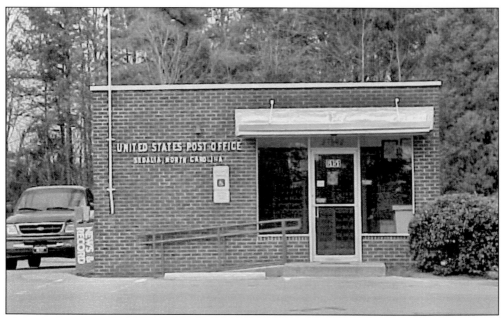

This photograph shows the United States Post Office in Sedalia. The official dedication services were held on May 28, 1966. Persons participating in the program included Elsie Andrews Paisley, Sedalia postmistress; Charles W. Bundridge, assistant to the president of Palmer Memorial Institute; J. Tracy Moore, Greensboro postmaster; Prince E. Smith, master of ceremonies; and the Honorable Horace R. Kornegay, who gave the address. The Sedalia Singers of PMI performed in the program. (Charlotte Hawkins Brown Museum.)

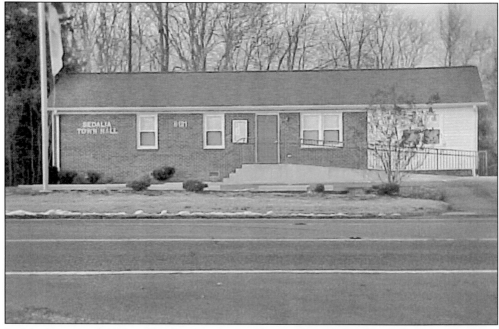

Sedalia Town Hall is the official meeting space for the town council and local government. It was officially opened in 2000. (Charlotte Hawkins Brown Museum.)

Five

PMI STUDENT LIFE

"The end of all education is to teach one to live completely, to find his highest expressions of all that is noble and good. Education, no matter to what degree it may extend, is a failure unless it helps the individual to build character, and gives to that individual the opportunity to discover truths and express ideas according to the light he possesses. Character does not just happen. It is the result of careful, painstaking development. The qualities we desire in children reach their highest peak only when someone with these self-same qualities directs the activities that develop them."

Dr. Charlotte Hawkins Brown

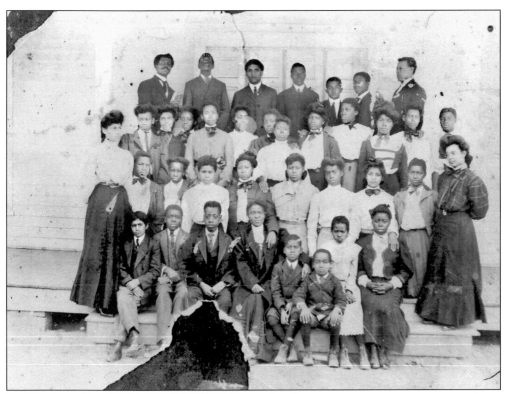

In this early photo of the student body taken in front of Memorial Hall, Dr. Charlotte Hawkins Brown is seated on the front row, fourth from the left. Also pictured are two early teachers on each end of the second row, c. 1907. (Charlotte Hawkins Brown Museum.)

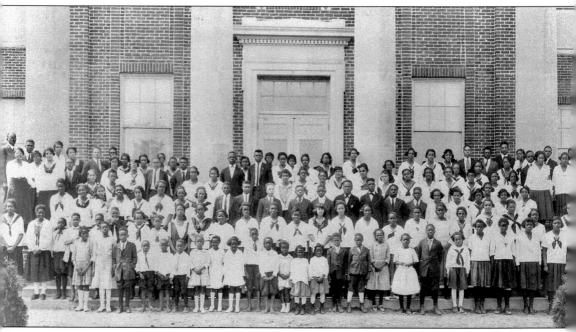

This is a photo of the student body taken in front of the Alice Freeman Palmer Building *c.* 1924. Dr. Brown and other faculty members stand in the back row on the left. (Charlotte Hawkins Brown Museum.)

The Class of 1926 poses on the side steps of the Alice Freeman Palmer Building. (Gladys Brown Rennick.)

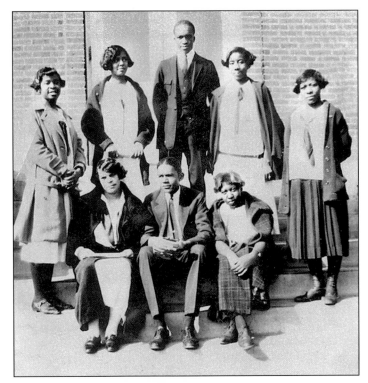

This picture of the student body was taken in the mid-1910s. (Charlotte Hawkins Brown Museum.)

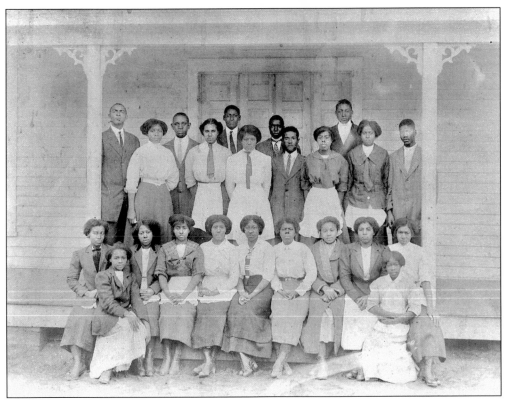

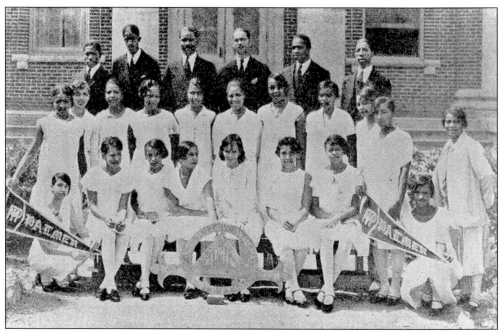

Proud members of the graduating class of 1930 are pictured with Dr. Brown (on the right). (Greensboro Library.)

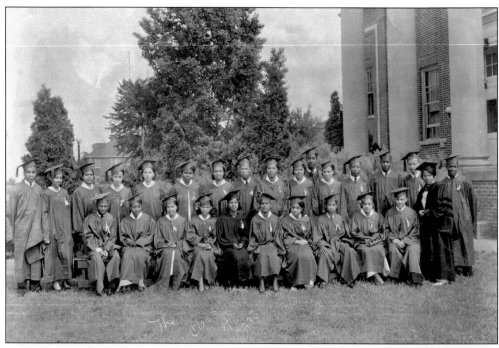

This is the graduating class of 1933; Dr. Brown is on the front row to the right wearing her doctoral robe. On the second row, three students are identified as Helen Brown (fourth from the left), Carol Brice (sixth from the left), and Gladys Brown (fourth from the right.) (Gladys Brown Rennick)

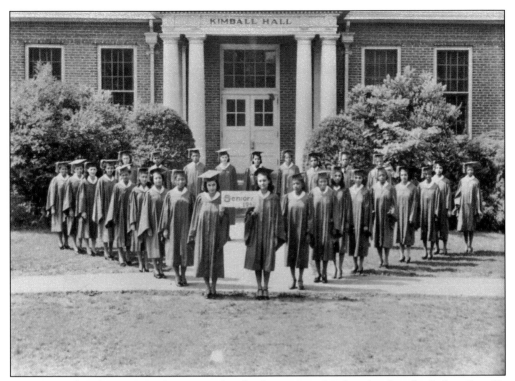

The Class of 1942 poses in the "Triangle of Achievement." Palmer's triangle, "educationally efficient, culturally secure, and religiously sincere," is symbolized by this formation. (Charlotte Hawkins Brown Museum.)

Pictured here is a graduating class from the 1940s. (Charlotte Hawkins Brown Museum.)

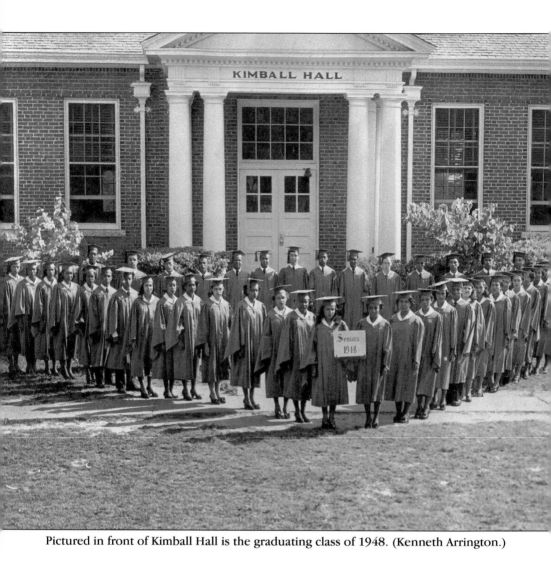

Pictured in front of Kimball Hall is the graduating class of 1948. (Kenneth Arrington.)

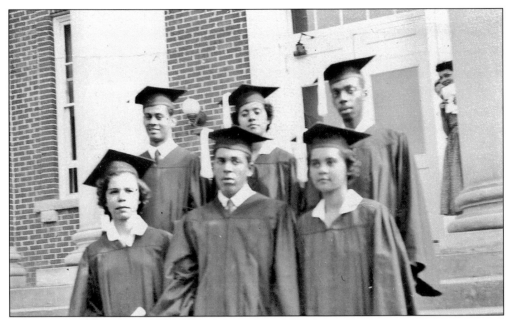

Pictured here are six members of the class of 1952; they are all from foreign countries. From left to right are (front row) Anna Anderson, Henry Talbot, and Anna Cooper; (back row) Emil Montas, Joan Swenson, and Jacques Sabastian. (Nathaniel Lacy/Charlotte Hawkins Brown Museum.)

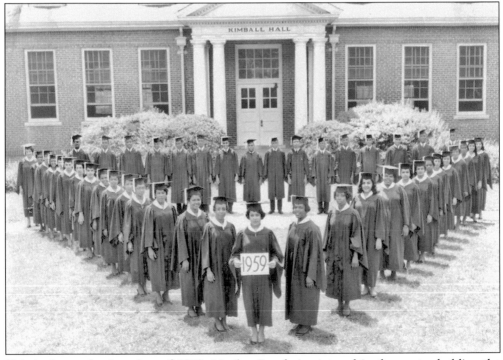

This is the graduating class of 1959; Marilyn Bundy is pictured in the center holding the sign. (Marilyn Bundy Peters.)

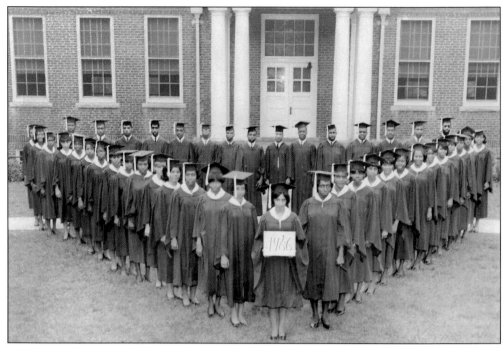

This is the graduating class of 1966; pictured eighth on the right is Claudia Totton, a third generation Palmerite and the granddaughter of Palmer's first graduate, Zula Clapp Totton. (William Mason.)

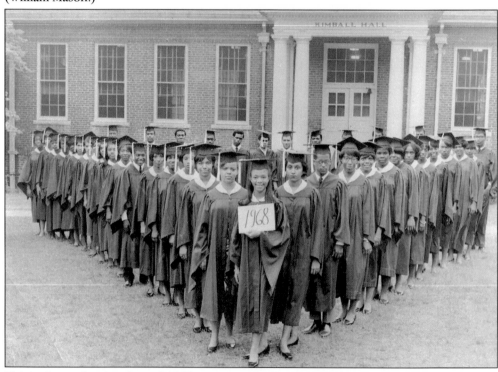

This is the graduating class of 1968. (Frances Darden Crump.)

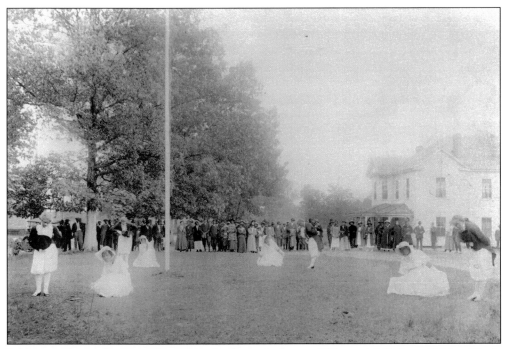

Palmer students dance a minuet on the lawn in front of Memorial Hall, *c.* 1930s. (Maria Hawkins Cole; Charlotte Hawkins Brown Museum.)

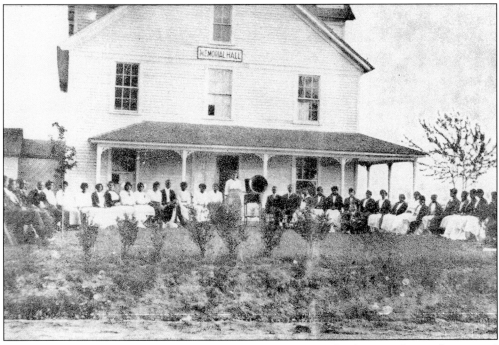

The Palmer students seen here are enjoying a concert on the lawn in front of Memorial Hall, *c.* 1916. Although the school focuses on industrial and domestic skills, Dr. Brown introduced Latin and fine arts into the curriculum. (Charlotte Hawkins Brown Museum.)

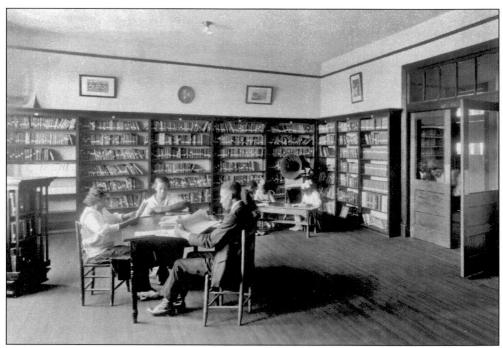

Students study in the George Close Library in the Alice Freeman Palmer Building, *c.* 1925. Note the art hanging on the wall. (Charlotte Hawkins Brown Museum.)

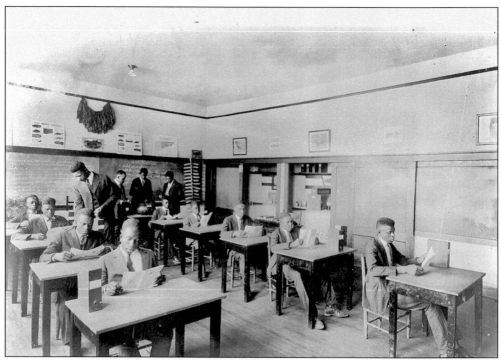

Students participate in an agriculture class. Note the tobacco hanging on the wall in the back of the room. (Charlotte Hawkins Brown Museum.)

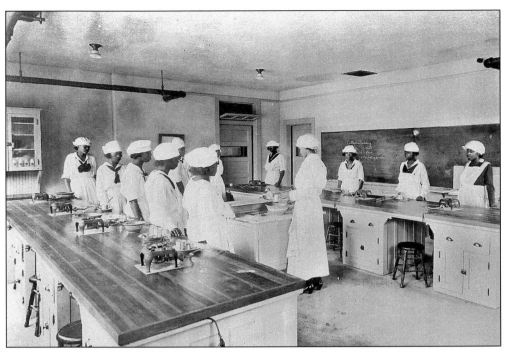

Here students participate in a domestic science cooking class, *c*. 1923. (Charlotte Hawkins Brown Museum.)

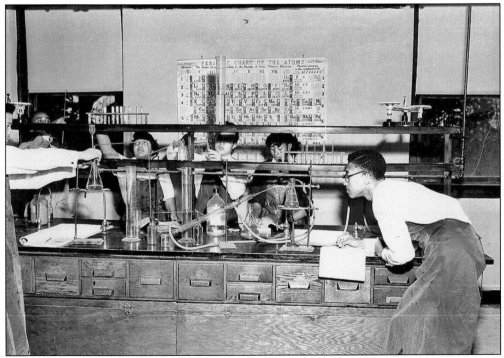

This image depicts students engaged in chemistry class, *c*. 1947. (Griffith Davis Collection, Duke University.)

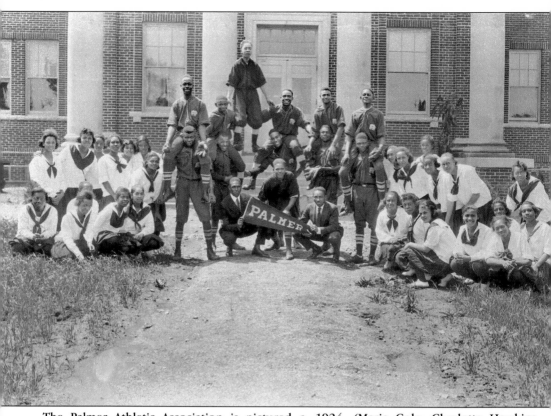

The Palmer Athletic Association is pictured *c*. 1924. (Maria Cole; Charlotte Hawkins Brown Museum.)

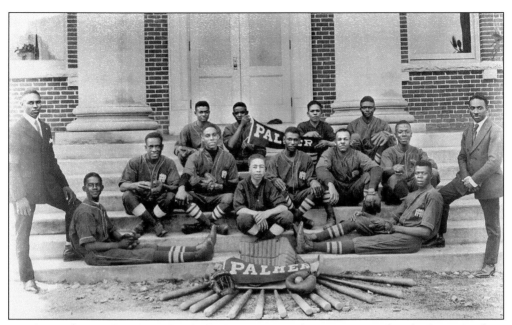

Members of an early Palmer baseball team pose on the steps *c*. 1924. (Charlotte Hawkins Brown Museum.)

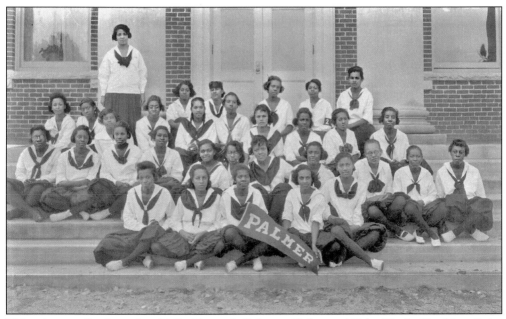

This picture displays the Girl's Physical Culture Club, *c*. 1924. (Maria Hawkins Cole; Charlotte Hawkins Brown Museum.)

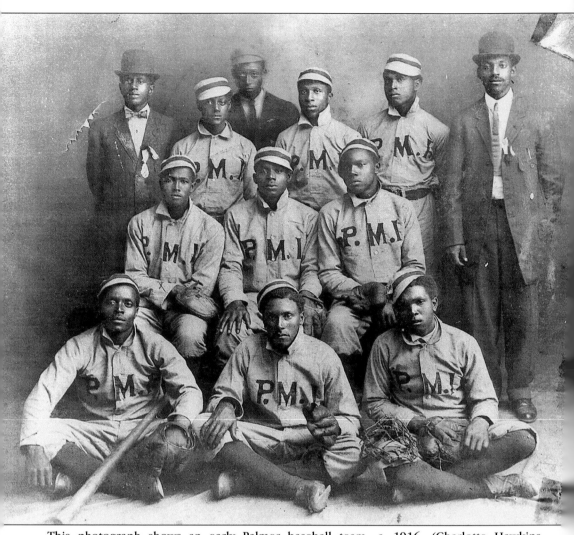

This photograph shows an early Palmer baseball team, c. 1916. (Charlotte Hawkins Brown Museum.)

Boxing was offered for a few years in the 1950s. This *c*. 1950 photograph is from a newspaper clipping. (Charlotte Hawkins Brown Museum.)

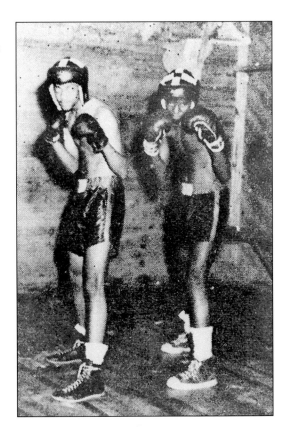

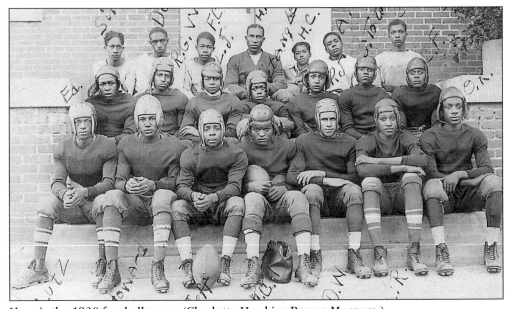

Here is the 1930 football team. (Charlotte Hawkins Brown Museum.)

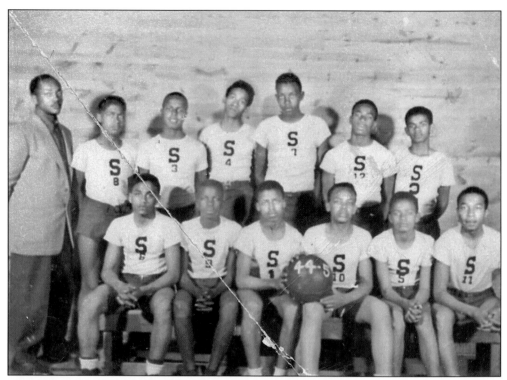

This photo is of the 1944–1945 Sedalia Trojans, with their coach Olvin McBarnette, a member of Palmer's Junior Class. The team was formed to give sub-freshman extracurricular activity. (Olvin McBarnette.)

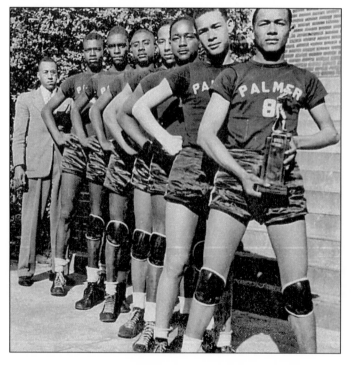

The 1945 Basketball Tournament Champions, pictured from front to back, are Matt Williams, Louis Raiford, Olvin McBarnette, Gerald Clark, Jessie Adams, Harry Bright, Quentin North, and Coach Charley Grant. (Olvin McBarnette.)

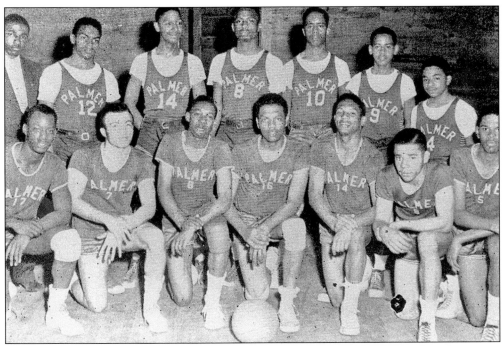

These students made up PMI's 1953 basketball team. (Charlotte Hawkins Brown Museum.)

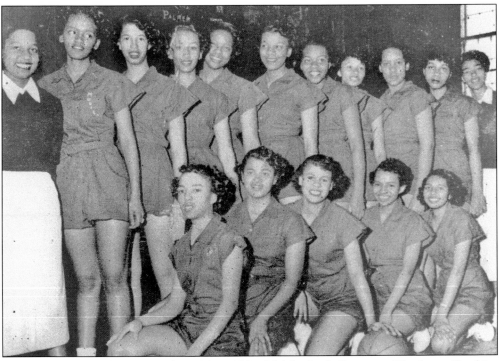

This photograph showcases the 1952–1953 girls' basketball team. (Charlotte Hawkins Brown Museum.)

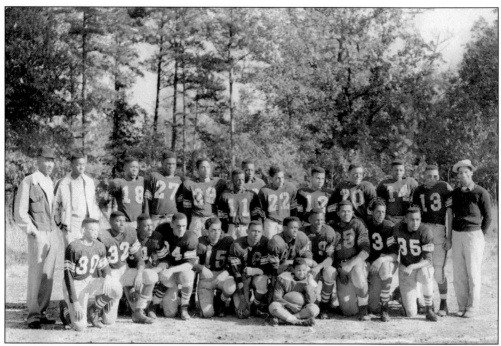

In this 1955 football team photo, pictured in the front center is John P. Hawkins. Coach Charles Bundridge is located on the back row on the left. (Charlotte Hawkins Brown Museum.)

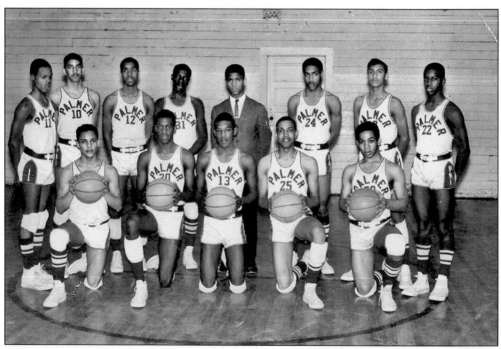

Posing for the camera are the members of the 1965–1966 boys' basketball team. (Charlotte Hawkins Brown Museum.)

Loretta Martin and John C. "Skeepie" Scarborough III are pictured at the 1965 prom. (Loretta Martin Green.)

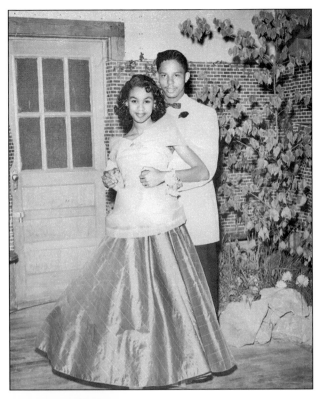

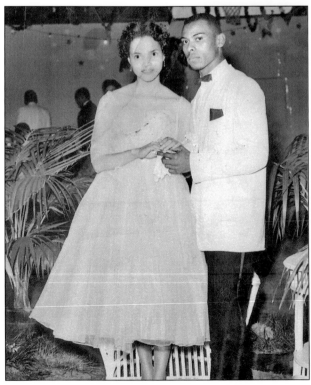

This is a 1957 prom picture of Josephine Harmon and John P. Hawkins. (John P. Hawkins.)

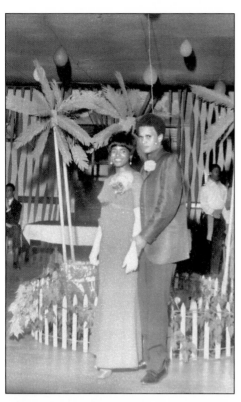

Melonie Williams and Hank Gaddis pose at the 1968 prom. (Melonie Williams.)

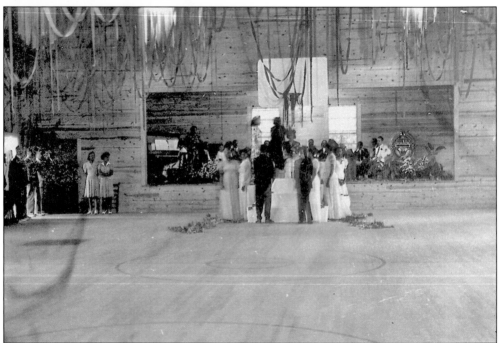

The gym is decorated for the prom in this 1940s photograph. Note the band on the stage and the crowning of the prom queen. (Charlotte Hawkins Brown Museum.)

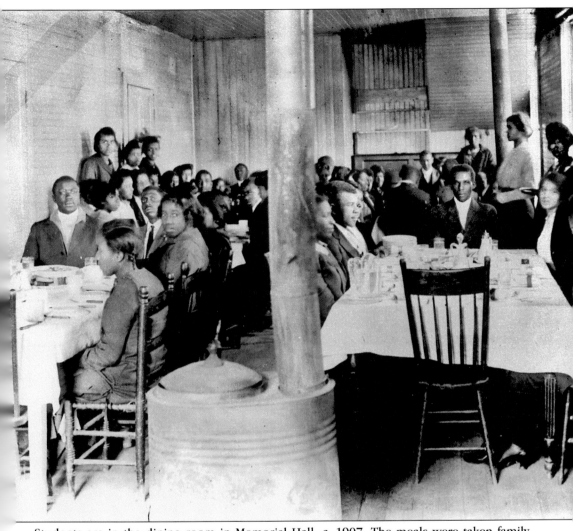

Students are in the dining room in Memorial Hall, *c.* 1907. The meals were taken family style and continued in this fashion throughout the life of the school. (Charlotte Hawkins Brown Museum.)

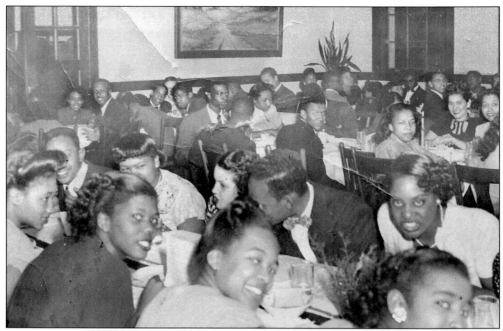

This is a 1940s scene of students in the dining hall. (Olvin McBarnette.)

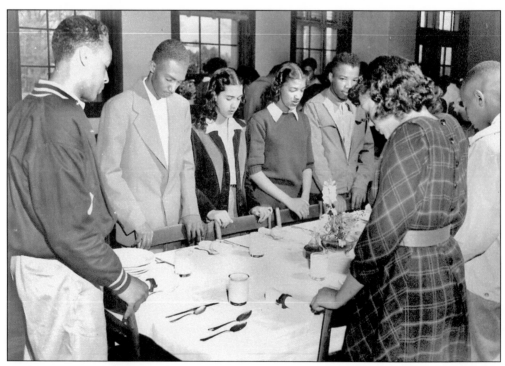

Students are seen praying before the evening meal in Kimball Hall in 1947. (Griffith Davis Collection, Duke University.)

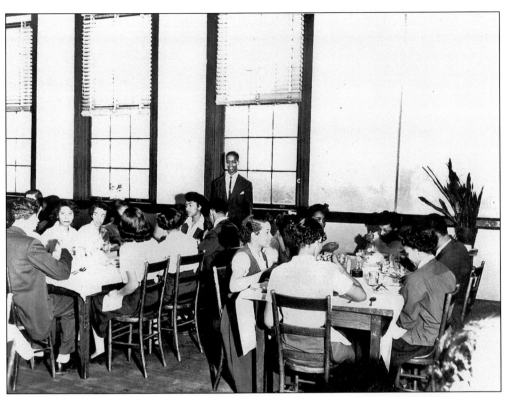

Another scene of the dining hall was captured in 1954. (Alex Rivera.)

The dining hall waiters posed for this picture in 1954. (Alex Rivera.)

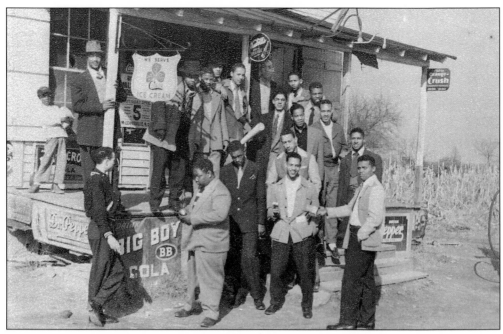

Palmer boys are seen hanging out in front of Paisley's store across from the campus, *c*. 1945. (Olvin McBarnette.)

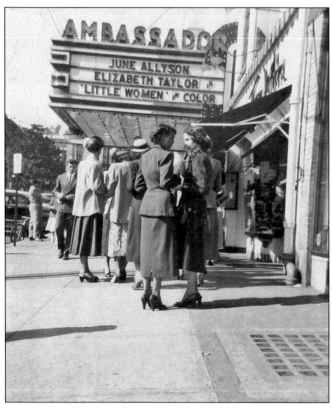

Students visit the Ambassador Theater in Greensboro in 1949. (Nathaniel Lacy/Charlotte Hawkins Brown Museum.)

Students are pictured in front of Kimball Hall; note the letter sweaters. Pictured from left to right are unidentified, LaVerne Gee, unidentified, Clyde Golden, DeLayfayette Davis, Gwen Gatewood, James Lockhart, Grace Pryce, and George Terrell. (Barbara Blayton Richardson.)

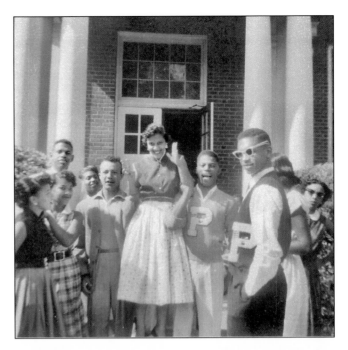

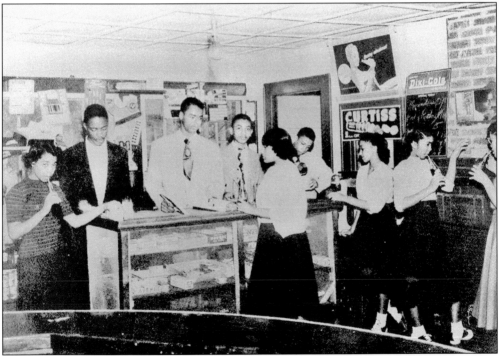

In this photo from the 1953 yearbook, one can see students inside the Tea House. The store was designed to teach Palmer students commerce. Each year they were given a budget to run the store, and a faculty member supervised the process. It was a privilege for Palmer students to go the Tea House. Sub-freshmen were allowed to go certain hours and upperclassmen in the evening. (Charlotte Hawkins Brown Museum.)

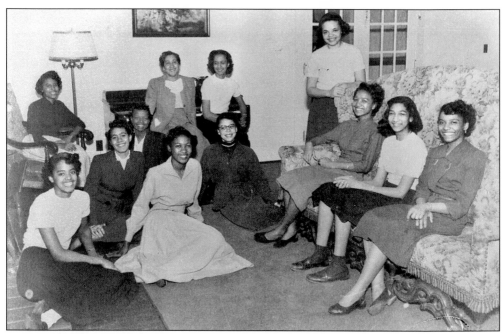

The Galen Stone Hall Council was made up of dormitory residents, who ensured all rules and regulations of the campus were enforced. If students broke the rules, the council determined their punishments. The usual punishment was losing privileges and extra chores. From left to right are, (seated on the floor) Gwendolyn Gatewood, Olivette Jones, unidentified, Barbara Dendy, and Madelyn Barnhill; (seated on couch) Yvonne Pettus, Kate Bulls, and Ruby Davis; (seated along back wall) Mercedes Mitchell, Mrs. Kimble (dean of girls), and Helen Plater; (standing) Barbara Blayton. (Charlotte Hawkins Brown Museum.)

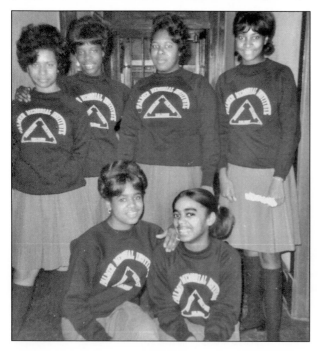

Palmer girls are pictured inside Galen Stone Hall, *c.* 1960. (Carol Hurdle Evans.)

The Palmer school bus, named "Brown Sugar," is shown *c.* 1965. All buses at Palmer had the same name, it was a tradition started by Dr. Brown and students. (Melonie Williams.)

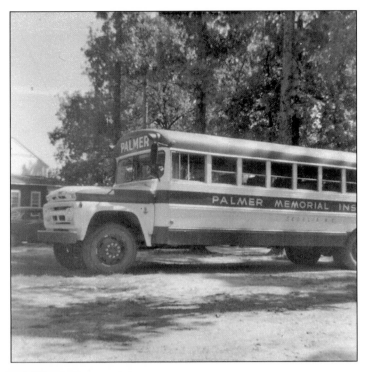

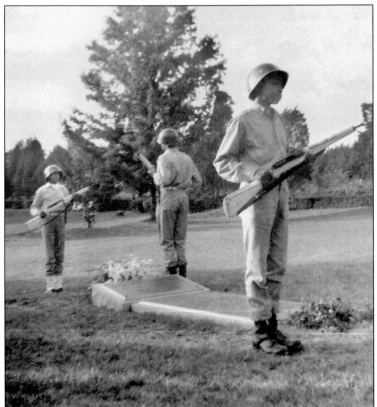

Palmer Troopers guard Dr. Brown's gravesite at the Founder's Day Celebration, *c.* 1965. pictured from left to right are Madison Mullens, Tommy Davis, and George Smith. (Melonie Williams.)

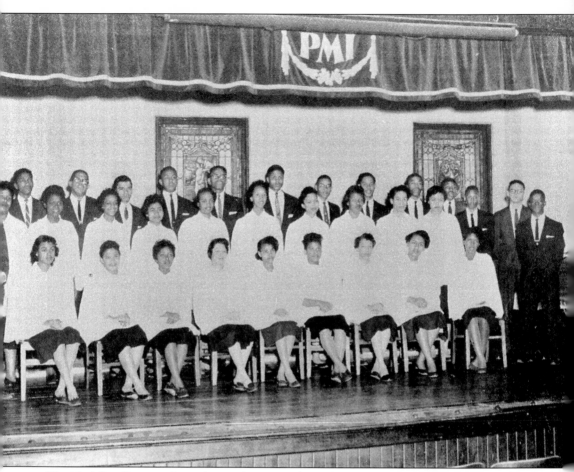

The Sedalia Singers throughout the years have been instrumental in raising funds, recognition, and acclaim for the institution. The reputation of the singers grew largely in the Eastern states and Northern cities. In the 1930s Dr. Brown used the Sedalia Singers to spread her philosophy of religion and culture. Each year the singers performed concerts in such places as Symphony Hall, Boston; Town Hall, New York; and the White House. They sang traditional Negro spirituals. In later years the music department presented dramatized spirituals, which consisted of interpretations of the old songs by groups of dancers. These were performed in festivals throughout North Carolina and in other venues. (Greensboro Public Library.)

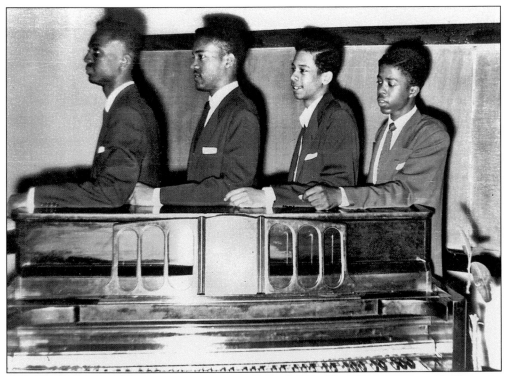

This 1950s photograph shows the "Boys' Quartet" of PMI. All students were required to take some form of music appreciation that included piano, voice, harmony, public school music, and music appreciation. (Charlotte Hawkins Brown Museum.)

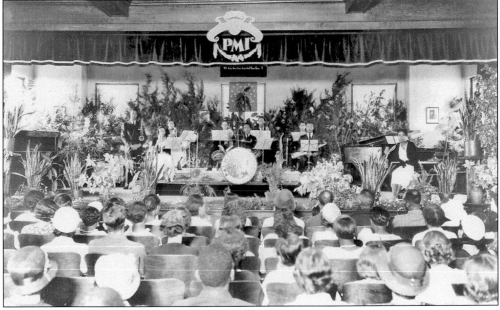

A Palmer orchestra concert was performed in the Wellesley Auditorium, *c*. 1930. (Charlotte Hawkins Brown Museum.)

Dr. Charlotte Hawkins Brown and Wilhelmina Crosson (center) are seen greeting students in the receiving line of Canary Cottage in this 1954 photograph. (Alex Rivera.)

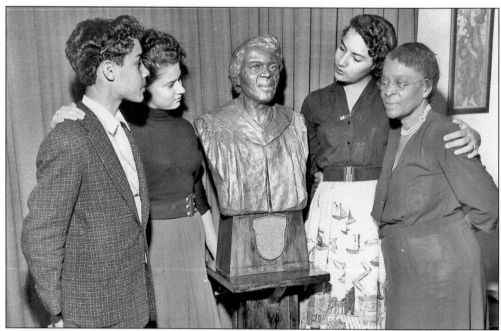

This 1954 photograph taken in Canary Cottage captures students gathered around the bust of Dr. Charlotte Hawkins Brown, with the founder to the right looking on. (Alex Rivera.)

In 1948 Nat King Cole and Maria Hawkins married in a widely publicized ceremony at the Abyssinia Baptist Church in Harlem. En route to their honeymoon in Acapulco, Mexico, they visited Maria's aunt Dr. Brown, who did not attend the wedding. Dr. Brown arranged a reception for the couple in Canary Cottage and numerous students had opportunities to meet them. (Bernice Wilson Jackson.)

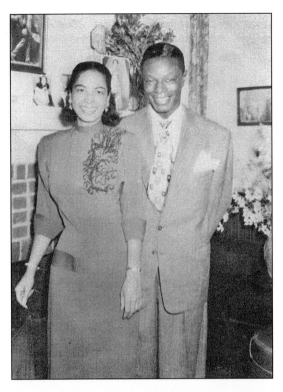

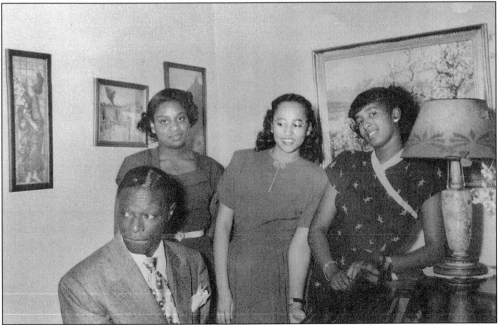

In this photograph students sit in awe of the presence of Nat King Cole on the campus for his wedding reception. From left to right are Nat "King" Cole, Bernice Wilson, Delores Creswell, and an unidentified student, who served at the reception. (Bernice Wilson Jackson.)

113

Here, students pose in a 1960s photograph. Note the style of dress and the afros, which were representative of this era. (Greensboro Public Library.)

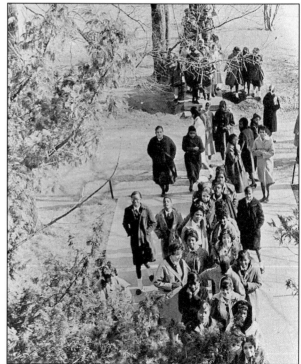

This 1960s photograph shows female students walking toward the girls' entrance of the Alice Freeman Palmer Building. (Greensboro Public Library.)

Six

CHURCH LIFE

"I sing because I'm happy
I sing because I'm free
For His eye is on the sparrow
And I know He watches me"
Lines from *"His Eye is On The Sparrow"*

Missionary Esther Douglass came to the present-day Sedalia area in 1870 as an employee of the American Missionary Association (AMA). She soon established a church, and the people of this area began meeting in the Old Foundry where guns and ammunition for the Civil War had been made. A place was cleared among the oaks, and the stumps were removed by Allen Roan and others to make way for the erection of Bethany Congregational Church, now Bethany United Church of Christ. The Bethany building was officially dedicated in January 1874; Douglass served as both teacher and lay preacher to the congregation. The school held at the church was called Bethany Institute. She simultaneously formed Wadsworth Congregational Church in Whitsett, approximately five miles away. (Bethany United Church of Christ.)

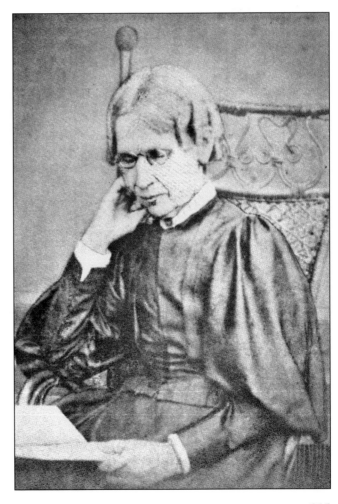

In 1897 Rev. Manual Liston Baldwin became the principal and minister at Bethany Normal and Industrial Institute. He was an 1896 graduate of Talladega College in Alabama, where he was ordained as an American Missionary Association missionary. He was married to Edith Baldwin, and they were the parents of five children. He served as pastor of Bethany Church from 1897 until 1903 and had a limited role in the institute up until that time. In 1904 he and his wife donated 15 acres to the trustees of Palmer Memorial Institute for the development of the school. He was also a gifted photographer and ran a photography business at 209 East Market Street in Greensboro. (Charlotte Hawkins Brown Museum.)

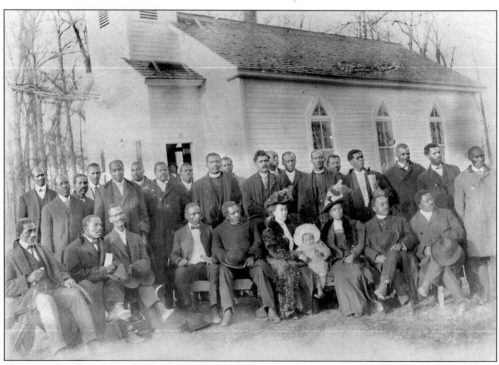

This early 1900s photograph shows members of the Bethany Church gathered on the lawn of the church. A school had been housed in the local church since the 1870s. Charlotte Hawkins (Brown), seen seated third from the left, began teaching on October 12, 1901, and became a leader in the church. (Charlotte Hawkins Brown Museum.)

Rev. and Mrs. Leslie R. Maye Sr. are seen in this early 1900s photograph. He was a graduate of Talladega College and served as a minister in the Congregational Churches. (Maye Family Collection.)

This is Rev. Dr. John Brice, a graduate of Knoxville College and veteran of World War I, where he served as a chaplain. He later became pastor of Bethany Church and served from 1926 until 1950. He was a member of the Palmer Memorial Institute faculty and later served in administrative capacities there. Under his leadership the church was remodeled, adding electric lights, a furnace, a choir stand, and pews to replace the old student desk flap seat. He was instrumental in connecting the church, community, and Palmer Memorial Institute together. At the school he planted oak trees, shrubs, and flowers that made the campus pleasing to visitors and the community. (Andre D. Vann.)

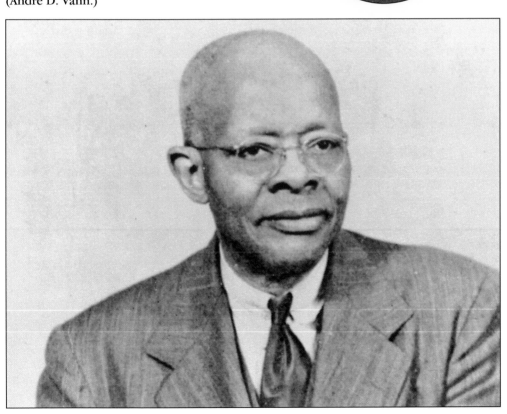

Miss Willa Aquilla McIver is seen in this photograph outside the Bethany Congregational Church. She was a graduate of Atlanta University and later received a professional diploma from New York University. She taught for many years at Sedalia School and Latin at Palmer Memorial Institute. (Bethany United Church of Christ.)

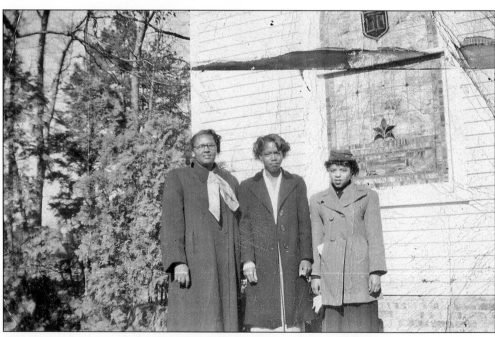

Shown in this photograph are Beatrice Maye, Jewel Fuller, and Florence Matier in front of Bethany Congregational Church. (Bethany United Church of Christ.)

This is a 1940s photograph of, from left to right, (standing) Leroy Hannah, unidentified, and Roy Foust; (kneeling) Jewel Fuller and Gretta Fuller. (Bethany United Church of Christ.)

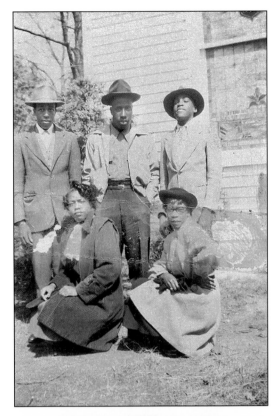

In this photograph Rev. Waddell Bonner performs baptism rites over baby Wilhelmina Robertson in Bethany United Church of Christ. From left to right are Dan Johnson, Zula C. Totton, Beatrice M. Robertson, Ernest Fuller, Reverend Bonner, baby Robertson, and Rebecca Fuller. (Totton Family Collection)

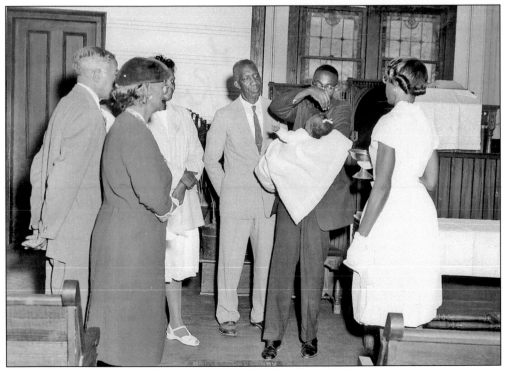

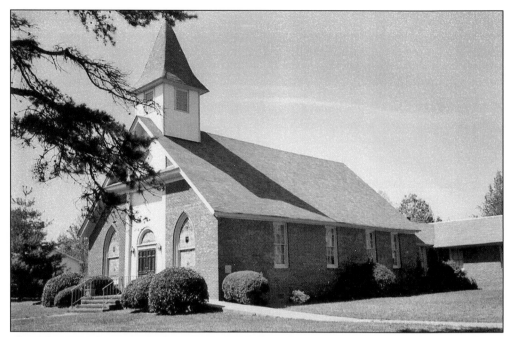

This photograph captures the beauty of present-day Bethany United Church of Christ, which served as the inspiration for Dr. Charlotte Hawkins Brown to found Palmer Memorial Institute. In 2002, Rev. George k. Richmond, a Sedalia resident, became pastor. (Webb Family Collection.)

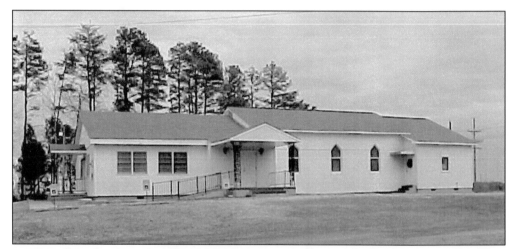

In 1910, four families, the Ellis, Maynard, Rogers, and Totton families, got together to establish a church. Charlotte Hawkins Brown, a close friend of Adline Maynard, gave the founders permission to use the land on which the church now stands. The families cut brush and poles and built a brush arbor, and they began worshiping in what was to become now St. James United Methodist Episcopal Church. They worked night and day to erect a building. When they worked at night, Adline Maynard held the lantern so that the men could see how to nail the boards down. They used boards for seats—until Brown gave the church some school benches. Rev. Cicero McLaughlin was the first minister. In 1995, Rev. Paul A. Bethel was appointed to St. James. (Tracey Burns-Vann.)

Seven

SEDALIA TODAY

"Because of Dr. Brown and the earlier Sedalia residents, the town continues to prosper. We still have the rural setting with all city amenities within ten miles in either direction. The majority of the property is privately owned and residents pride themselves on the town's accomplishments. It has become a destination place for retirees and young families. The Charlotte Hawkins Brown Museum attracts visitors from all walks of life, and it amazes people to see a campus the size of a small college located in such a small town. Sedalia is expected to continue to grow, but we want to keep the small town flavor."

Jeanne Lanier Rudd, mayor, Town of Sedalia

Margaret M. Hill Gibbs (1924–1986), a native of Greensboro, was educated at PMI(class of 1941). She received her bachelor's degree from Bennett College and master's degree from NC A&T State University. She was married to Warmoth T. Gibbs Jr. and was the mother of six children: Brenda, Sheila, Marece, Annette, Warmoth III, and Wilmote. She was an elementary school teacher and was actively involved in the educational, religious, and civic endeavors of the community. She is kindly regarded as the guiding spirit behind the development of the Charlotte Hawkins Brown Historic Site, and she was a co-founder and president of the Charlotte Hawkins Brown Historical Foundation, Inc. Hill, along with Maria Hawkins Cole, niece of Dr. Brown and widow of Nat "King" Cole, organized alumni and friends of Brown together to convince the North Carolina Department of Cultural Resources to designate the Palmer campus a historic site. (Charlotte Hawkins Brown Museum.)

Former North Carolina senator William "Bill" Martin, along with Palmer graduate and North Carolina representative H.M. "Mickey" Michaux, were instrumental in establishing the historical site. In 1983 Martin sponsored a bill to establish a historical site to Dr. Brown. He requested and received an appropriation of $67,377 for planning. Martin and Michaux introduced bills for $500,000 to purchase land and operate the site. The General Assembly approved $400,000 for land acquisition and site development. Later, Marie Gibbs and Dr. Burleigh Webb rallied local citizens to support the site by establishing the Charlotte Hawkins Brown Historical Foundation, Inc. as a non-profit organization. (William "Bill" Martin.)

North Carolina representative Henry McKinley "Mickey" Michaux Jr., distinguished civic leader and 1948 graduate of PMI, worked along with Sen. Bill Martin to gain recognition for Dr. Brown and Palmer. A graduate of North Carolina Central University, he received his bachelor's and juris doctorate degree from North Carolina College (now North Carolina Carolina Central University). He went on to become the first black federal prosecutor in the South and has been elected to numerous terms in the North Carolina House, representing Durham County. (H. M. "Mickey" Michaux.)

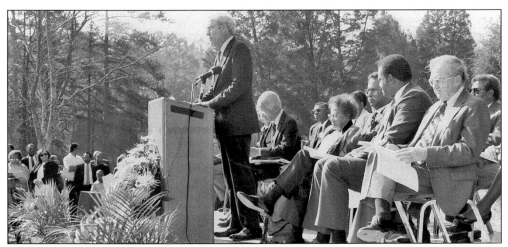

On Saturday, November 7, 1987, the Charlotte Hawkins Brown Memorial officially opened as an agency of the Department of Cultural Resources, with Annette Gibbs, project director. The 1 p.m. ceremony on the lawn featured Bob Jordan, North Carolina lieutenant governor. The site is located at the Old Palmer Memorial Institute campus in Sedalia. It is North Carolina's first historic site honoring an African American and the first to honor a woman. It features a museum, a visitor's reception center, and a gift shop commemorating Dr. Brown and Palmer in the renovated Carrie M. Stone Teacher's Cottage. The Charlotte Hawkins Brown Historical Foundation, Inc. was instrumental in establishing the first African-American historic site in North Carolina. (Charlotte Hawkins Brown Museum.)

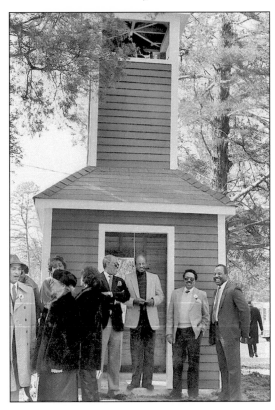

This photograph shows PMI alumni and friends gathered at the restored Bell Tower on the campus of the Charlotte Hawkins Brown Memorial in 1989. The Bell Tower was built in 1922 and is located behind Kimball Hall. Campus activities were controlled by the bell from the tower, which when rung signaled time for classes, meals, sporting events, lights out, and all other functions of the Palmer Memorial Institute. In its earliest years of the school, the Bell Tower was also used by the Sedalia community to signal when to come in from the fields for lunch and dinner. The original bell is contained in the structure. The New York Chapter of the National Palmer Memorial Alumni Association spearheaded the drive for the restoration of the Bell Tower. Palmerites from across the nation responded to assist. (Charlotte Hawkins Brown Museum.)

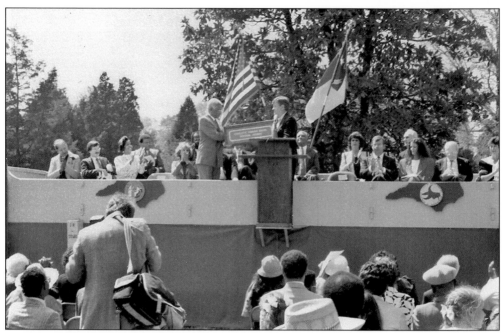

Former North Carolina governor Jim Martin presents a replica of the newly named stretch of the Charlotte Hawkins Brown Memorial Highway in 1988. Shown receiving the sign is Dr. Harold H. Webb, executive director of the Charlotte Hawkins Brown Foundation, Inc. (Charlotte Hawkins Brown Museum.)

Governor Martin is seen chatting with renowned author Alex Haley, who attended the dedication ceremony. (Charlotte Hawkins Brown Museum.)

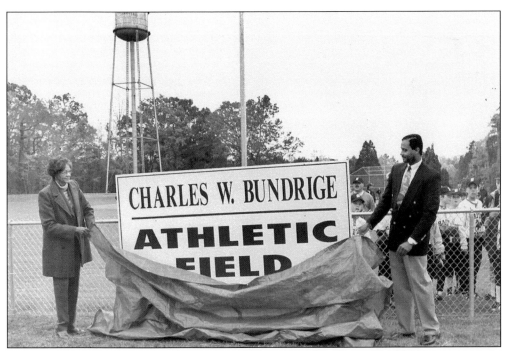

Novella Bundridge and son, Wesley, unveil sign of the Charles W. Bundridge Athletic Field in 1999. (Charlotte Hawkins Brown Museum.)

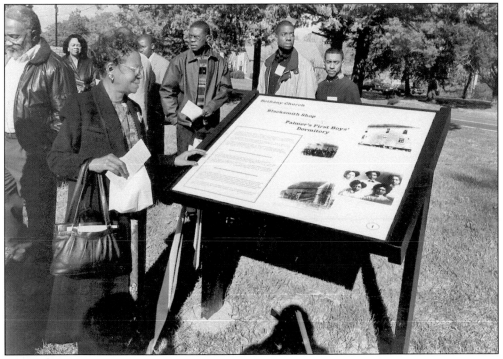

Visitors and conference participants view the new Wayside Exhibits. (Charlotte Hawkins Brown Museum.)

This photograph shows Ruth E. Smith as she is sworn in as postmaster for the Sedalia post office while her husband Prince E. Smith holds the Bible. She is sworn in by Greensboro's postal official, Dorothye M. Zane. From 1955 until 1965 Prince E. Smith was the agriculture teacher at Sedalia High School. He later taught agriculture at Northeast Senior High School. He became the director of federal programs for Guilford County schools and worked in the central office until retirement. He has served on the Guilford County Planning and Development Board for many years. He was also a member of the Guilford County Board of Adjustment and served as vice chairman of the board. (Ruth and Prince E. Smith.)

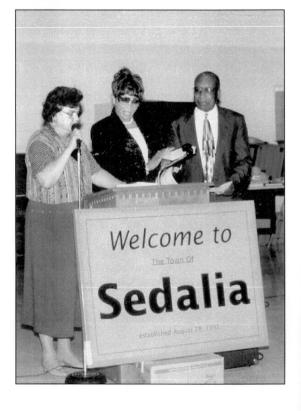

Sedalia was incorporated on August 28, 1997. The photograph shows the swearing-in ceremony for the first mayor of Sedalia, Ruth E. Smith, by the Guilford County clerk Norma Bodsford, of the mayor's office. To the right within the photo is her husband Prince E. Smith holding the Bible. (Ruth E. Smith.)

Henry Blackmon has had a long and distinguished career in the Sedalia community since moving here in 1925. In 1959 he purchased D.L. Morgan's property and built his home there. He became a member of Sedalia's first town council and was officially sworn in on September 29, 1997. In 2002 he and others were instrumental in helping secure Sedalia's first traffic light at the intersection of Sedalia and Burlington Roads. (Henry Blackmon.)

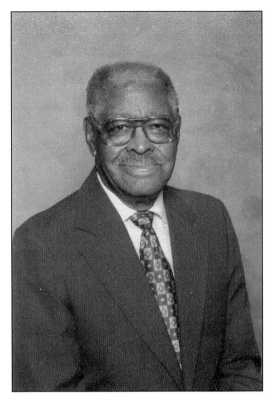

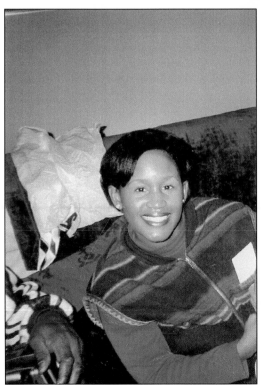

Tanae Jones Rascoe is the daughter of Robert and Ophelia Fuller Jones of the Sedalia community. She graduated from Eastern Guilford High School and attended NC A&T State University and then transferred to UNC-Greensboro. She became the second town clerk of Sedalia in August 2002. She is a member of the North Carolina Association of Municipal Clerks. She is responsible for the town records, council minutes, and the upkeep of the town hall. Tanae's grandfather and uncles attended Palmer Memorial Institute. (Ophelia Fuller Jones.)

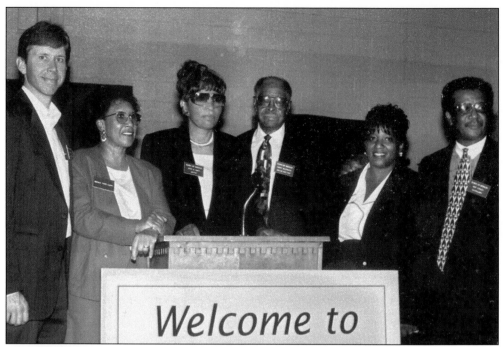

The first town council of Sedalia is pictured here. From left to right are Duane Bryant, Helen Quick-Brooks (town clerk), Ruth Smith (mayor), Henry Blackmon, (mayor pro-tem), Myra S. Lynn, and Emmanuel "Skip" Corley.

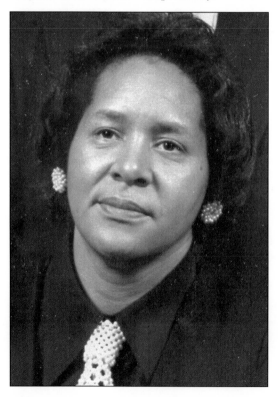

Jeanne Lanier Rudd wears many hats in Sedalia. She is the mayor, the president of the Charlotte Hawkins Brown Historical Foundation, Inc., the retired manager of the Charlotte Hawkins Brown Museum, and Palmer heir. Currently serving in the third year of a four-year term as mayor, she attended PMI and later graduated from the high school division of Immanuel Lutheran College and from NC A&T State University. A member of St. James United Methodist Church for 53 years, Jeanne married James Rudd and has one son, James Rudd Jr. Her father, William Lanier Sr., graduated from PMI in 1922. He served as alumni director prior to Palmer's closing, and he retired as the principal of Sedalia School. Jeanne served as president of the Charlotte Hawkins Brown Historical Foundation, Inc. when the school became a historic site. She is founder and director of the Brown Memorial Singers. (Jeanne L. Rudd.)